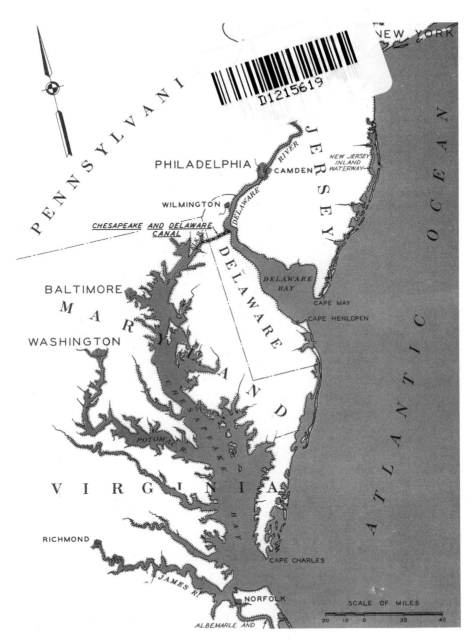

A map of the peninsula formed by the eastern shore of Maryland, the eastern shore of Virginia and the state of Delaware. The Chesapeake Bay lies to the west and the Delaware Bay and Atlantic Ocean to the east. The Chesapeake and Delaware Canal is shown cutting across the narrow neck at the northern extreme of the peninsula.

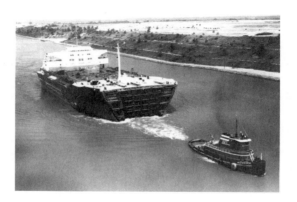

A tanker ship is towed through the modern canal. The width is 450 feet with a 36-foot depth. The canal's banks have been terraced to reduce erosion, a constant problem during the waterway's two-hundred-year existence.

A HISTORY
OF THE
CHESAPEAKE &
DELAWARE CANAL

DAVID A. BERRY

Charleston · London

THE
History
PRESS

Published by The History Press
Charleston, SC 29403
www.historypress.net

Cover image: A cargo ship transits the Chesapeake and Delaware Canal, passing under
one of the lift bridges constructed to provide crossings for highways and railroads.
Images on front and back cover courtesy of the Army Corps of Engineers, Chesapeake City, Maryland.

All images, except where noted, are courtesy of the Army Corps of Engineers,
Chesapeake City, Maryland.

First published 2010

Manufactured in the United States

ISBN 978.1.59629.864.4

Library of Congress CIP data applied for.

*To Chris; without your help, I would not have been alive to write this book.
My love always.*

CONTENTS

ACKNOWLEDGEMENTS

I wish to acknowledge that the books of Ralph D. Gray, Robert Hazel and Edward J. Ludwig III were invaluable in the creation of this volume and to thank Dave Hawley and the other staff members at the U.S. Army Corps of Engineering's Chesapeake and Delaware Canal Project Office in Chesapeake City, Maryland, for their assistance.

Canal Days

Delaware, our nation's first state, is almost triangular in shape. A quick glance at a map will show that it's wider at the southern end, narrowing at its northern end to only a few miles. If you lay a Maryland map next to it, you will see that the peninsula separating the Delaware and Chesapeake Bays is only fourteen miles wide at this northern extreme and that the two bodies of water are less than a day's walk apart. Due to the vision of a number of men, this narrow neck of land has been an important part of the growth of the United States.

Thirty thousand acres of the land on this neck was once called Bohemia Manor. It was owned by Czech-born Dutch diplomat Augustine Herman. It had been a gift to Herman from Lord Baltimore for negotiating the resolution of a land dispute. The only cost was producing the first accurate map of what would become Cecil County, Maryland. He named a small village established on the northern border of his holdings Bohemia. It was about 1661 when Mr. Herman rode one of his horses along this northern border and became the first European to publicly declare that it would be a perfect location for a canal connecting the two most important bodies of water in early America, the Delaware and the Chesapeake Bays.

Augustine Herman died in 1686, but in the twenty-first century, residents of northern Maryland and Delaware know that the biggest open-air party of the year happens on the last weekend in June. The result of Herman's vision, the Chesapeake and Delaware Canal, has passed through the town of Chesapeake City, once known as Bohemia, following close to Herman's

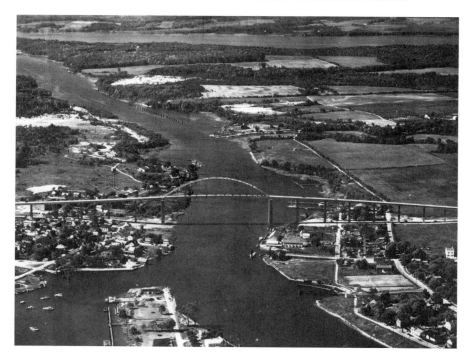

An aerial view of the western end of the canal. South Chesapeake City is on the left and north Chesapeake City is on the right. The bridge connects two points of Maryland Route 213. The body of water on the left is the engineering basin, and ahead is Back Creek.

original suggested route, since 1829. The town celebrates this major feature of its community with Canal Days. Hundreds of land-based travelers come to shop at the booths set up along the town's streets, with vendors selling a full menu of food, drink and craft items. There are dozens of boats in the engineering basin on the south shore of the canal, where the local bar pours drinks by the gallon. The 2009 party was subdued by previous standards due to an increased police presence, but it was still the talk of the area for a month afterward.

It would be unusual if more than a handful of the hundreds of weekend visitors knew the history of what they were celebrating. Few would know that the canal concept was first proposed in the 1600s. Augustine Herman is unknown to most people, though Bohemia continues as the name of the river Herman's manor house overlooked, as well as two local schools. They would be surprised to learn that Ben Franklin later became a major proponent for the canal's construction. He did not live to see the opening in 1829 but would be pleased that it is still functional 180 years later. Few

would know that the Chesapeake and Delaware Canal (better known as the C&D) is one of only two sea level canals operating in the United States and is the last working canal built during this country's canal-building frenzy in the early 1800s. The C&D has saved shippers millions of dollars by providing a three-hundred-mile shortcut between the major ports of Philadelphia and Baltimore.

The Chesapeake and Delaware Canal runs at sea level for the fourteen miles between the Delaware River at Reedy Point in the east and the Back Creek branch of the Elk River in Maryland in the west. It was first constructed with four locks but was rebuilt as a sea level canal in the 1920s. It is 450 feet wide, almost 400 feet wider than the original 66 feet of width at the surface. The original canal narrowed to 36 feet at the bottom, with a depth of 10 feet. It is 35 feet deep in 2009 and can accommodate all but the largest oceangoing vessels. Today, ships traverse the C&D under their own power, but teams of mules pulled the boats in the early years. Bridges have been built across the canal since the beginning, and bridges have been knocked down since the beginning. There are now five highway crossings soaring above the canal. The one railroad bridge provides 133 feet of vertical clearance when it opens for the estimated fifteen thousand annual transits.

The C&D Canal marks both a geographical and cultural boundary. The British surveyors and engineers Charles Mason and Jeremiah Dixon began

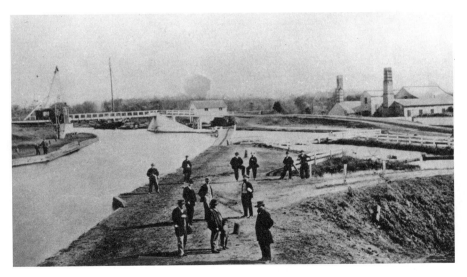

A view of the canal and Chesapeake City in the 1800s. A work crew is standing by in the image, and in the background you can see the Long Bridge that crossed the canal for many years.

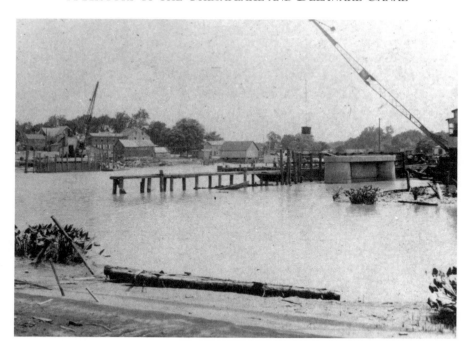

Another view of the canal taken in the late 1800s that shows some of the wharfs where passenger and cargo vessels could tie up.

laying out the boundary line that still bears their names in 1763. Part of the project was determining the tangent line that became the north–south border between Maryland's Eastern Shore and the state of Delaware. That line bisects the Chesapeake and Delaware Canal, placing roughly half of the waterway in each state. The tangent continues north for another fifteen miles before it heads west and marks the Maryland-Pennsylvania border, but many locals feel that the real Mason-Dixon line is the canal. North of it, the land is rolling hills and small farms. Slavery was never much of a factor. It has become highly urbanized over the last fifty years. The land south of the canal is the flat, sandy soils of the Atlantic Coastal Plain. The farms tend to be larger than their northern counterparts. It is still much more rural than the northern end. Only Dover, Delaware, and Salisbury, Maryland, are large enough to be called cities. Slavery was once common south of the canal. Though neither Maryland nor Delaware seceded from the Union during the Civil War, the northern counties were much more pro-Union than the southern.

We take the canal for granted today, forgetting that the project was a massive undertaking in the years before power equipment. More than

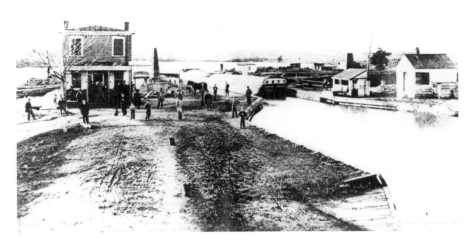

The locks in Chesapeake City are shown in this image from the 1800s. A barge is in the process of transiting through, while the lock crew waits for the lock to fill. A lack of sufficient water plagued the canal for its first one hundred years.

three thousand men worked on the original dig for wages of $0.75 per day. It cost $2.5 million to build, a staggering amount of money in 1829. But it is important to note that the Chesapeake and Delaware Canal has never really been finished. It has been pushed and pulled, widened and moved, dredged and automated—and there are still ongoing studies to complete further improvements.

Like most major building projects, the Chesapeake & Delaware is an engineering feat, but it is more a story of the people who envisioned it, the people who designed it, the men who built it, the men who supported it through its early days of financial failure, the towns that benefit from it and the people who have used it over the last two centuries.

BEFORE THE CANAL

M ost of the state of Delaware, as well as the eastern shores of both Maryland and Virginia, is part of the geological region called the coastal plain. Thousands of fossils from the Late Cretaceous period were found each time the C&D Canal was widened and deepened. The fossils are of marine life, plants and animals and show that 70 million years ago the oceans reached much farther inland. Three successive glaciers covered the area that is now referred to as the Delmarva Peninsula. They scoured the land as they retreated, leaving behind the sandy soil that characterizes the peninsula. The land seldom rises more than one hundred feet above sea level for its entire 180-mile length. The widest section is 60 miles, but the peninsula narrows to only 14 miles at the northern end. That narrow neck lies on the fall line that divides the sandy coastal plain from the Piedmont province. That fall line is marked by a narrow, eighty-foot-high ridge of limestone.

The glaciers also left behind the many rivers and creeks that empty into the Chesapeake and Delaware Bays. The Elk River, the Bohemia River and Back Creek on the Chesapeake side and the Appoquinimink River, Christiana River, Duck and St. Georges Creeks on the Delaware further reduce the actual distance between the two great bodies of water. The earliest residents who occupied the peninsula ten thousand years before the first Europeans arrived made use of game trails to move between the two bays.

The last Native Americans to occupy the area were the Susquehannock on the Chesapeake side and the Delaware (they called themselves Leni-Lenape) on the Delaware side. They were associated with different

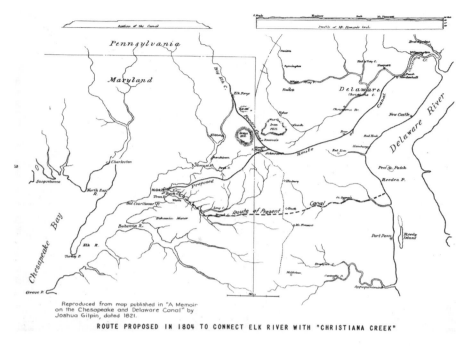

Reproduced from map published in "A Memoir on the Chesapeake and Delaware Canal" by Joshua Gilpin, dated 1821.

ROUTE PROPOSED IN 1804 TO CONNECT ELK RIVER WITH "CHRISTIANA CREEK"

This image shows the route the original canal was supposed to take when work was begun in 1804. It was to connect the Elk River in Maryland and Christiana River in Delaware. The dotted line to the south of the proposed canal is where the current waterway runs.

tribes—the Susquehannock with the Iroquois and the Delaware with the Algonquin—and, as a result, were often at war. When not fighting, they were trading, and in both cases, they traveled along four major game paths that ran below the ridge of limestone.

The first Europeans began arriving in the early 1600s when Captain John Smith explored the Chesapeake and Henry Hudson sailed up the Delaware. There is no record that either man crossed the Delmarva, but by the 1630s, British settlers were occupying what is now Cecil County, Maryland. The Dutch had colonized Delaware, which they called Zwaanendael. The Dutch were soon replaced by Swedes, who renamed the land New Sweden, but they were in turn unseated by the returning Dutch. Regardless of who was currently in charge, the game trails became trading routes between the two colonies. Dr. Benjamin Bullivant wrote in a travel account in 1697, "[A]bout 8 myles below new Castle is a Creeke, by wch you may come to a neck of Land 12 myles over Crosse wch are drawn goods to & from Mary Land & Sloopes also of 30 tunns are carried over land in this place on certaine sleds drawn by Oxen & launched again into

18

the water of ye other Side." The trails were also used by Native American war parties that attacked the Europeans with increasing frequency as more settlers arrived.

The first settlers saw the potential of a canal to cross the peninsula. The last governor of New Sweden, Johan Rising, wrote in 1654 to his superiors in Sweden about his belief in expanding the settlement to protect itself from the British in Virginia. Settling the upper Christiana Valley would also make it possible "to carry on trade with them, making a passage from their river, the Elk, the headwaters of the Chesapeake Bay, into the said kill by which we could bring the Virginia goods here and store them, and load our ships with them for a return cargo."

Augustine Herman, the lord of Bohemia Manor located on the neck of Delmarva, took up the cause in 1661 when he wrote to an official of the Dutch settlements on the Delaware, "The Minquaskil and the aforesaid Bohemia River [where Herman had located his estate home] run there within a league of each other, from which we shall in time have communications with each other by water, which may serve as encouragement to the inhabitants of New Netherlands." Herman would repeat his belief in the economic possibilities of a canal for the rest of his life but would have to be content with the cart paths between Bohemia Manor and the Delaware and Chesapeake Bays.

Other travelers and settlers expressed the desirability of a waterway across the northern neck of the Delmarva, but these dreams were impossible to realize because the technology of canal building was nonexistent in this country in the seventeenth century. The engineering of a complex lock system, such as those in limited use in Europe, had yet to be developed in the New World, and the solutions to the problem associated with the digging of a usable, and stable, canal were not understood. It would be the eighteenth century before science began to catch up with the vision.

A SHORT HISTORY OF CANALS

Canals date back to about 4000 BC, when the first known canal was built in Mesopotamia. It, along with most ancient canals, was primarily built for irrigation and, as a consequence, required little engineering knowledge. The first canals built for river transport were in China. The Hong Gua, or Canal of the Wild Geese, was constructed about 481–221 BC. It connected the ancient states of Song, Zang, Chen, Cai, Cao and Wei. The Grand Canal of China is still the longest canal in the world at 1,115 miles. Sections were begun as early as 486 BC, but it was not completed until AD 609.

Canals became the method of choice for Muslim engineers to manage irrigation of the fields of the Middle East, an example being the Thal Canal in Pakistan. Their influence spread, and the building of European canals was believed to have started in Spain after the Islamic invasions. Europe during the Middle Ages had an extremely poor road structure. Canals provided cheaper and easier transportation. The first artificial canal, the Naviglio Grande, was built near Milan between 1127 and 1257. The Dutch of the Netherlands and Flanders began building canals to drain the polders, the low-lying land between dykes, in order to expand their towns and villages.

A simple lock technology was developed about the twelfth century and allowed for canals to be constructed in places where land elevations were restrictive. The Grand Canal of China and the Stecknitz Canal in Germany used single-gate, or flash, locks. The Braire Canal, which connected the Loire and Seine Rivers in France and was built in 1642, used pound locks, the two-door system first developed by the Chinese (though the Dutch had

used the method as early as 1373). The most ambitious project, finished in 1683, was Canal du Midi, connecting the Mediterranean and the Atlantic and which had eight locks, a 520-foot tunnel and three major aqueducts.

Canals continued to be constructed sporadically throughout Europe, but the advent of the Industrial Revolution initiated the largest program of canal development, particularly in Britain and the colonies that were to become the United States. The Stankey Canal in 1757, followed four years later by the Bridgewater Canal, cut the cost of coal transportation between Liverpool and Manchester by half, leading to a canal-building frenzy that saw more than one hundred canals built in Britain between 1760 and 1820.

The same issues that had plagued the European countries, primarily a lack of good roads, were a problem in Britain's North American colonies. Goods needed to be transported great distances, and the cheapest, most available method was water. The trouble was that many of the rivers became impassable a few short miles from their mouths. The land elevation changes created fall lines, and waterfalls blocked any access. The Susquehanna River, which runs 440 miles from upstate New York through Pennsylvania and into Maryland, was blocked by the Conowingo Falls, first known as Smyth Falls, just 12 miles from where it empties into the Chesapeake Bay, rendering the

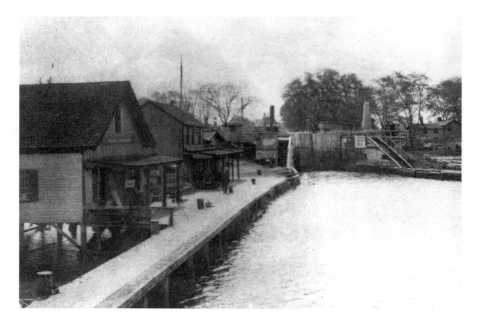

The entrance to the locks at Chesapeake City, the canal town now located where Augustine Herman's Bohemia Manor was originally settled.

rest of the 428 miles useless to extended navigation. By 1793, there were thirty canal companies operating in eight states. Most proved to be financial failures, but their efforts had a major impact on the economic development of the new United States.

One of the first charters was issued to the Potowmack Company in 1785, with George Washington listed as one of the partners. The company's purpose was to build the 340-mile Chesapeake and Ohio Canal that would connect the Chesapeake Bay to the Ohio River. The final construction fell short of its lofty goals. It began in Georgetown, near Washington, D.C., and ended in Cumberland, Maryland. It cost $22 million to build and lasted as a working canal for ninety-six years.

Canal construction reached its zenith in the early years of the nineteenth century. Total length of the canals in the United States grew from fewer than 100 miles to over 4,000. Much-improved construction techniques helped fuel this boom, but economics were a factor. The 363-mile Erie Canal that connected New York to the Great Lakes had a significant impact on reducing the costs of goods shipped between regions.

Canals continued to be constructed throughout the United States, Canada, Europe and Japan, but the boom days would soon come to an end as the railroads began their significant expansion. Many railroads used the canals to transport the material needed to build the tracks, and then when they became operational, they ran the canals out of business with their lower costs. Major canals were still constructed—the Suez in 1869 and the Panama in 1914 are two major examples—but many fell into disrepair or became tourist attractions, not used for working transportation. Europe's canals are still used both for freight and cruise passengers, but few survive as working canals in the United States.

The C&D is an exception, due to the foresight of Thomas Gilpin, a Pennsylvania-based landowner, amateur scientist, engineer and miller who was the first person to seriously propose that the vision of early settlers, such as Augustine Herman, be realized.

SURVEYS AND DELAYS

R alph D. Gray, in his excellent book *The National Waterway: A History of the Chesapeake and Delaware Canal, 1769–1965*, calls Thomas Gilpin the grandfather of the C&D Canal. Gilpin was born a Quaker in Pennsylvania in 1728 and grew up to become a wealthy landowner, merchant and miller. He received little in the way of formal education but was a voracious reader on his own and soon became well versed in subjects as diverse as the wheat fly, hydraulic wind pumps and the migration of the herring.

The Gilpin family owned land in the colonies of Delaware, Maryland and Pennsylvania, including several tracts of land that bordered creeks that might be inlets or outlets for the cross-Delmarva canal he began to promote. The driving force was his realization that most of the goods produced in Pennsylvania were being transported down the Susquehanna River and on to Baltimore, which had grown from two hundred people in 1750 to a city of more than six thousand just ten years later. Gilpin proposed the building of the canal to recapture some of the trade he believed rightfully belonged to Philadelphia, a city in which he had resided since 1764. He began to write articles promoting the canal's construction and commissioned surveys for as many as five possible routes for the waterway. Some of these routes included land that he owned along Duck Creek and other locations. Gilpin saw the larger picture, the increase in trade, but he wanted to reap some of the financial rewards, too, an attitude that others in the future would more aggressively adopt. Gilpin even went to England to study the Bridgewater Canal that had been finished in 1761.

Gilpin's articles had an effect on others in Philadelphia's merchant class, and support for such a project grew. He presented his plans to the American Philosophical Society in January 1769. The society was impressed enough that it referred the project out to two committees, the American Improvements and the Trade and Commerce, with the objective being to establish an organization to actually build the canal. They raised more than £200 to finance an eight-man Committee of Survey to conduct several surveys in 1769–70.

The first route surveyed was between the Bohemia River on the Chesapeake side and Appoquinimink River on the eastern end. This was compared to a route surveyed by Gilpin between the Chester River and Duck Creek. The first was deemed too expensive, requiring £40,000 to build. Gilpin's southerly route was less costly but too far from Philadelphia for effective trade.

More possible routes were surveyed during the winter of 1770, including one from Peach Bottom Ferry on the Susquehanna River to the town of Christiana Bridge (modern Christiana) in New Castle County, Delaware. The last of the four surveys was the most elaborate. It was another northern route, also terminating at Christiana Bridge at the eastern end but using the natural water of Back Creek and the Elk River on the Maryland side. The survey committees' recommendation was to use one of the routes terminating at Christiana Bridge since it was near Philadelphia and would be perfect for capturing the trade of the Susquehanna River. The Peach Bottom–Christiana Bridge route was considered by many to be the most viable, but the approaching conflict with Great Britain meant that nothing more was done for more than a decade. Thomas Gilpin was sent into exile in Virginia during the Revolutionary War due to his refusal to sign a declaration of loyalty. He died there in 1778, though his son, Joshua, would become the most knowledgeable member of the Chesapeake and Delaware Canal Company when it was later formed.

The Pennsylvania legislature revived the project in 1785 when members suggested that the three states, Maryland, Delaware and Pennsylvania, should appoint commissioners to study the feasibility of a canal to improve trade and communication between Philadelphia and the lower Susquehanna. The three states met in November 1786 at Wilmington. The meeting received widespread support from such leaders as George Washington, James Madison and Ben Franklin but ended without resolution.

Delaware and Maryland believed that the construction of the canal would dampen their trade. Delaware was more interested in road construction

than canals, and as Washington predicted, Maryland refused Pennsylvania permission to "open communication between the Chesapeake and Delaware by way of the Elk and Christiana Rivers." The proposed canal was perceived as a major threat to Baltimore's trade interests with the Susquehanna.

The Wilmington conference came to nothing, but the United States went on an improvement binge in the last decade of the eighteenth century. Hundreds of miles of roads, bridges, turnpikes and canals were constructed. Three or four artificial waterways were planned in each of the thirteen states. The C&D plans were pulled from the drawer and found to be the most promising of all the proposed canal projects, but the next steps were frustrated by the fact that the construction of the canal would cross two states, Delaware and Maryland, that had shown little interest in it. Pennsylvania was the driving force since it believed that the C&D would be a major factor in increasing trade. Maryland was still concerned with Baltimore, and Delaware was afraid of losing the lucrative carrying trade that had sprung up along the peninsula.

A special appeal was made to the millers along Brandywine Creek in Pennsylvania. If wheat from Maryland could be delivered cheaply, they could increase production of flour by 300,000 to 500,000 barrels annually. Estimates noted that wheat shipped east and milled flour shipped west through a cross-peninsula canal could be done at one-sixth the cost of hauling the products overland.

The appeal had little impact. Delaware was firm. An alternative plan was proposed by the governor of Pennsylvania that the official stance of Delaware be bypassed by having the land for the canal purchased privately. James Higgins offered to make the purchases, providing that he could get a loan from Pennsylvania and receive compensation from the tolls expected to be collected by passing barges. Higgins, not surprisingly, already owned the land at the head of the Bohemia River in Maryland.

Pennsylvania refused Higgins's generous offer but continued to work on the proposed canal. In 1793, the Pennsylvania Society for Promoting the Improvement of Roads and Inland Navigation made a proposal to gain the cooperation of Maryland and Delaware. A meeting was again held in Wilmington, where commissioners from the three states drew up a program in which all three states would work to open the Susquehanna from Swatara Creek to the Maryland line. The jointly organized charter company would also build a Chesapeake–Delaware canal. The citizens of all three states would own shares. These plans, despite the enthusiasm, came to nothing and the projects languished.

Ironically, the building and completion in 1796 of the Lancaster Turnpike, one of the country's first major highways, renewed interest in other improved inland communication, and calls for a canal across Delmarva were renewed. Maryland and Delaware began negotiating concessions from Pennsylvania in return for supporting the cross-Delmarva canal. Pennsylvania had opened up the idea of building the C&D Canal, but this time Maryland was on board, going so far as to charter its own canal company on December 7, 1799. The charter would remain dormant until both Pennsylvania and Delaware passed similar acts of incorporation. In addition, Maryland wanted the lower portion of the Susquehanna River cleared of obstructions. That would allow boats descending the river to Port Deposit, Maryland, a passage clear of rocks and rapids. The law authorizing the canal company was contingent on Pennsylvania acting accordingly.

Pennsylvania was ready to act but realized that Delaware had yet to respond. A bill to authorize a canal charter was introduced to the Delaware legislature in January 1800. It passed the House of Representatives, but the Senate refused until a substantial number of compromises could be made. The bill was resubmitted in 1801 and this time passed both houses due to a new political climate. The Federalists were attacked by the Democrats for not passing the bill the previous year. To regain popularity, they passed the same bill. The process was helped by the lobbying efforts of three Pennsylvania commissioners who came to Dover to arrange terms that the Delawareans found favorable. The two main obstacles—providing Delaware a chance to study land records in Pennsylvania in hopes of resolving some border disputes and the lifting of several quarantines that Pennsylvania had imposed on its smaller neighbor—were resolved. Despite the agreement, it would not be until February 27, 1802, that Delaware was completely satisfied and the canal charter was activated in all three states. The Chesapeake and Delaware Canal Company was officially opened for business.

A capitalization of $500,000—2,500 shares at $200 apiece—was authorized. When half of the shares were subscribed, actual work could begin. One year was allowed for the campaign to sell the shares. The initial concern was that there would be too many pledges, which proved to be an unnecessary worry. The first stockholder meeting was held in Wilmington on May 1, 1803; 1,400 shareholders attended and a slate of officers was elected. Joseph Tatnall from Wilmington was named president. Of the remaining nine officers, four were from Pennsylvania, three from Maryland and two from Delaware. The men elected were primarily merchants, millers or lawyers and were considered to be the pillars of their respective communities.

Almost 1,800 shares had been sold to 730 subscribers by the time of that first meeting. The total amount earned was $103,000, of which $76,000 existed in the form of a $5 payment due September 1. Plans were made to begin surveys as soon as possible. Another six-man Committee of Survey was organized in early June 1803. It set out to determine the most suitable route from the choices made in previous surveys. Four surveyors were authorized to be hired with an initial funding of $1,000, with the promise to increase that to $5,000 if need be. The chief surveyor would be Benjamin H. Latrobe, an architect, engineer and surveyor of some reputation. He would become the canal's first chief engineer when the initial dirt was moved in 1804.

The committee and the surveyors were concerned with several issues. One was explaining why the shortest line across the peninsula may not be the best. They felt that the average person would not understand the various factors—the condition of the soil, the elevation changes, available water supply and the location of land routes—that had to be included in any objective report. The entrances had to be deep and protected. The projected types of ships that would use the canal also had to be considered. The next year was spent looking for the best possible route.

The surveying team considered a sea level (or cut-through) canal, which would eliminate the need for locks. The only suitable location required a deep cut through the dividing ridge of the peninsula, but the costs were too great and the engineering standards of the day too weak to give that method serious thought. Latrobe thought that the cut through the limestone ridge alone would exhaust the entire capital of the company.

Some of the most persistent problems the committee faced were the influential landowners who wanted the canal to use property they owned and could sell at a profit. Latrobe would complain to Joshua Gilpin about the squabbles among the board of directors, each of whom wanted the canal to cross his property. The survey team spent a good deal of time and energy proving that several routes proposed by local interests were totally unfeasible.

Two finalists emerged from the surveys, the so-called lower and the upper routes, and both had passionate supporters. The upper route was to run from the Elk River to Christiana and empty into the Delaware directly at New Castle, or use the Christiana River. This was roughly the route first laid out in 1770 by the American Philosophical Society. The lower route was more direct and would run from Back Creek, a tributary of the Elk River, in the west to St. Georges Creek in Delaware. (Three other routes—from Frenchtown in Maryland to Hamburg on the Delaware Bay, from the Sassafras River through Georgetown, Maryland,

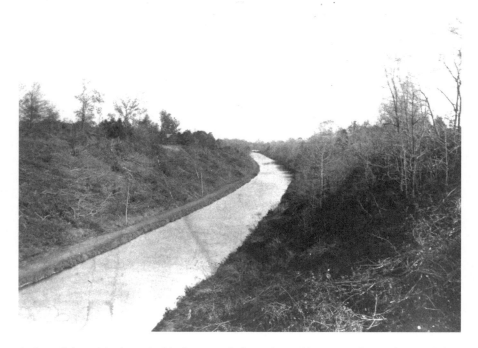

A view of the original canal with the towpath for mules and horses on the northern or left bank. *Courtesy of the Cecil County Historical Society.*

to Appoquinimink Creek and one located much farther south that used the Chester River to connect with Duck Creek at Bombay Hook in Delaware—were considered but rejected early in the process, as was the early choice, the route from the Bohemia River to Appoquinimink Creek.)

It was estimated that thirty-two surveys had been conducted, and it was almost impossible to find anyone in any of the three states who was totally impartial on the subject. Latrobe, the chief surveyor, had not stated his own preference, but William Duane, editor of the *Philadelphia Aurora*, found that there were few supporters for the shorter, lower route. Most people agreed that the western end of the canal should run from Bear Creek to Welsh Creek, but there were more arguments about the eastern terminus with New Castle, Red Hook and Wilmington, all under discussion. Duane accurately predicted that the Christiana route would end up being selected. The board of directors chose the upper route, with Welsh Point on the Elk River being the western termination, in November 1803. There was sufficient water in the Elk River to flood the proposed canal if a feeder canal was constructed from the Elk River to a reservoir that would be built near Glasgow, Delaware. The

feeder canal would also serve as a possible future canal into Pennsylvania. The eastern end was left as an open issue.

A new Committee of Purchase began buying the land rights and announced in April 1804 that all of the land for the feeder canal to run between Glasgow, Delaware, and Elk Forge had been secured, a claim that would shortly be proved false. Latrobe was authorized to hire six persons and equip them with three wheelbarrows, three crowbars, one long bar, six picks and a few sledgehammers, as well as wedges for splitting stone. They were to open a quarry to mine rock needed to build a viaduct over the Elk River. Latrobe and his team were also allowed to hire diggers to begin work on the feeder canal.

There would be several contractors, each responsible for a section of the canal. The canal company would supply the tools and housing for the workers. Advertisements ran in newspapers in Philadelphia, Wilmington and Baltimore calling for digging contractors and supplies. Latrobe, who had been named chief engineer of the canal company, selected nine initial contractors who he felt had the necessary resources and work ethic to complete the task. He knew most of the contractors personally and felt that he was getting the best workforce he could muster. Each of the digging firms brought thirty men. Robert Brooke, a Philadelphia surveyor, was hired as the clerk of the works; his role was to certify the work being completed by the contractors. The first dirt was dug in May 1804, and the longtime supporters of the canal believed that it would just be a few short years before goods would move seamlessly between Philadelphia and Baltimore. They would soon realize that things were not going to be that simple.

The first issue the canal company faced was a lack of housing for the workers who had been brought in for construction. The situation was so severe that a riot even developed between the diggers and the people of Elkton in October 1804. The next problem was that not all of the land had been acquired for the feeder canal, meaning that it could only be completed in disconnected sections. The major issue, though, was money. The company announced that only 2,100 shares had been sold and also that payments had been made on only 1,792 of the shares that were subscribed. The first year, Latrobe spent $85,000, leaving only $20,000 on hand in June 1805. Only 59 percent of the money due had been collected, and as a consequence, work rapidly ground to a halt.

It was time to take a step that would repeat itself a dozen times in the next 120 years: appeal to the government.

CHAPTER 5

THERE IS NOTHING NEW IN THE WORLD

Anyone who remembers 2008–9 knows how much controversy surrounded the decision by the federal government to invest billions of dollars in various private institutions and financial and automotive sectors that were deemed too big to fail. There is nothing new in the world. The C&D Canal Company spent the years between 1805 and 1825 trying to show the federal government and the various states that the canal project was too big to fail and needed government bailout money. The discussions and arguments were just as passionate two hundred years ago as they were the past eighteen months.

The first step the board of directors took was to solicit the legislatures of Pennsylvania and Delaware for funds. They were refused in early 1805. Work was continued on the feeder canal in the hopes that it would inspire the shareholders to pay for the shares they had bought, but by December 1805 Latrobe had to halt all work and let everyone go except for the company's officers.

Joshua Gilpin, Thomas's son, appealed to the secretary of the treasury, saying that the project was beyond the capabilities of any one state or community. His appeal fell on deaf ears, and there was no other choice but to go to Congress for funding. A presentation was made in December 1805. The request for financial aid was based on the fact that the canal was of national importance. James Bayard of Delaware asked his fellow Congressmen to come to the aid of the canal company, but many of the members thought that the request was unconstitutional and that the government could not invest in the stock of a private company.

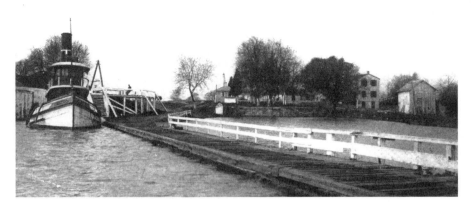

The locks at the small village of St. George. A tug is waiting as the lock is filled with water.

Overall, the House of Representatives felt that the project had merit as "an opening wedge for an extensive inland navigation which would at all times be of an immense advantage to the commercial as well as to the agricultural and manufacturing part of the community" and that it would be a major advantage during times of war but that the project was beyond the financial capabilities of the country at that time. The canal's petition, presented in March 1806, was the first of many until federal aid was finally allowed in 1825. Tools were sold, as well as some of the land already purchased. The $19,000 debt was resolved. Latrobe left the company in June 1806. The board of directors continued to meet over the next nineteen years, periodically appealing to various government entities for aid, but even the War of 1812, which showed how vital a canal could be to the country's security, failed to rouse any changes in Congress or the states. Joshua Gilpin, a canal advocate for forty years, was ready to give up his dream.

The twenty-year period between when the work on the C&D Canal was suspended and the introduction of federal aid marked an era of intense debate on a fundamental issue that we still struggle with today. Where should the line be drawn separating government intervention in private interests? Is it legal, or constitutional, for the federal government to own stock in a private enterprise? The proposed C&D Canal led the debate during this period because of the size of the project, its location and the fact that it would bring benefits to more than just the two states it would cross. Secretary of the Treasury Albert Gallatin released the "Report on Roads and Canals" in 1808 in which he called for federal aid to the project. It would be seventeen more years before his suggestions were adopted.

Many believed that the majority of the Senate was in favor of using government money to fund internal improvements, but efforts by Senators Bayard and Samuel White of Delaware, along with Henry Clay of Ohio, were met with vehement opposition by John Quincy Adams of Massachusetts. Adams succeeded, with help from fellow senators Uriah Tracey and James Hillhouse of Connecticut, in getting any and all canal resolutions tabled until further notice. New Hampshire senator William Plummer was not initially a supporter but changed his mind based on what he saw as the immense importance of inland navigation to the country's growth. He accused the bill's opponents of shirking from responsibility. Thomas Worthington of Ohio called for a motion, which was passed in March 1807, that would provide a complete analysis of the needed internal improvements. The secretary of the treasury was to produce the report, which came to be known as the "Report on Roads and Canals."

The concern about roads and transportation in the relatively new country was growing, but while plans were being drawn up for various projects, there was no coordination. Albert Gallatin began to accumulate his data. The final report was the first successful attempt in pulling all the efforts together in one document. The largest project called for in the report was a waterway that would allow unimpeded navigation, using four canals, between New England and the mid-Atlantic states. It was estimated that such an undertaking would cost $20 million. Gallatin suggested that $2 million be set aside each of the next ten years to fund the construction and that the federal government should provide most of the funding because the project was of national importance.

The coming War of 1812 put the Gallatin report on the back burners, not to be revived until the Bonus Bill was introduced by John C. Calhoun in 1816. That measure called for applying the bonus and dividends received from the Second National Bank of the United States to internal improvements. It passed both houses but was vetoed by President Madison on constitutional grounds.

There were several more attempts by the canal company to introduce legislation to provide aid for the defunct C&D Canal, but they met with resistance in each case, even with the claim by Secretary of War Calhoun that the inland navigation was of extreme importance to the security of the country. The other issue was that the major interest in the canal was located in Philadelphia, not in Washington, D.C., and many Congressmen felt that it should be left up to that state to complete the construction.

Much of the credit for reviving the interest in the canal project should go to an Irish immigrant, Mathew Carey, who stepped into the fray in the early 1820s. He had come to Philadelphia from Ireland at the age of twenty-five and became a printer, as well as a fiery, outspoken leader in the community. His major concern was the loss of trade with Baltimore. When his efforts to revive public support for the canal failed, he went into action and started the program that renewed subscriptions and led to the reorganization of the canal company in 1821. Joshua Gilpin was thrilled by the project's new life but was concerned that the American Philosophical Society was calling for yet another survey. Gilpin believed that such an effort would renew all of the local and parochial interests that had slowed the original construction. He also thought, and was soon proved correct, that the fervor in Philadelphia for the canal would signal to Washington that its help was not required. He said, "Without waiting for other aid, all other is hopeless."

Efforts were put in place to begin work. Many believed that the western end would remain on the Elk River, as outlined in 1804, and that the eastern end, in either New Castle or Wilmington, could be decided later. With Carey aggressively pursuing the construction and Gilpin recommending caution, the project went through several starts and stops. Carey went so far as to collect proxies from the Pennsylvania stockholders. He arrived at a shareholder/board of directors meeting, held in March 1821, and succeeded in unseating the existing board. It was replaced with sympathetic Philadelphians.

Carey's efforts were beginning to pay off. Surveys were being conducted, but money remained the major stumbling block. The new board was authorized in February 1822 to issue stock subscriptions worth $600,000. Many felt that it would take as little as two weeks to sell out the entire offer, but the initial interest produced only $20,000. Carey decided to once again go after state aid as the final solution in realizing his dream. This time he met with success. Between 1822 and 1824, the three states involved, Maryland, Delaware and Pennsylvania, pledged close to $200,000 with the contingency that another $200,000 would be obtained elsewhere.

Carey went into action to gain the interests of private citizens in purchasing stock. He believed that the 120,000 residents of Philadelphia could finance the canal without the help of Delaware and Maryland. He estimated that a total of $700,000 was needed to complete the project, and there was $287,000 on hand in 1822. Fundraising was slow that year, but on one day in 1823 he managed to collect $20,000 from just four men. He solicited major Philadelphia banks, which were initially not interested, but he managed to revive fundraising among the average citizens of the city,

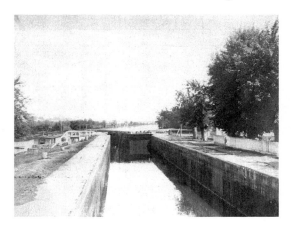

Chesapeake City is the western terminus of the C&D Canal, and originally Delaware City was the eastern end. This image shows the locks there. The small town was first known as Newbolt's Landing, but its name was changed because the town founders believed it would soon be a port that would rival Philadelphia.

obtaining more than $360,000 worth of pledges. He even approached the city's laborers, showing them how on a minimum wage they could afford to subscribe to one or two shares of stock; 220 people took him up on the single-share offers. Other nearby cities joined into the frenzy of stock buying. West Chester contributed $4,000 in one day, with Wilmington adding another $30,000 to the total.

The stockholder meeting held in July 1823 was a joyous occasion. It seemed assured, due to Carey's efforts, that the canal would go forward. Plans were set to resume work on the Chesapeake and Delaware Canal beginning in April 1824.

1825

A Pivotal Year

There may not be a more pivotal year in the history of the C&D Canal than 1825. Congress after a nineteen-year wait finally approved the first federal subscription of $300,000. Additionally, more work was completed on the canal that year than in any other. Finally, a lawsuit would be filed that would haunt the finances of the canal company for the next one hundred years.

The years between 1804 and 1825 saw more than a dozen appeals to Congress for canal funding. The major argument for federal support was the military significance of the canal. Supporters pointed to how different the War of 1812 would have been if the canal had been completed. Many others pointed out that while the three local states would indeed benefit, the entire country would receive increased trade and commerce from such a major inland navigation project, and no one private or local entity should be expected to take on such a financial burden without assistance.

The opponents threw the same arguments back at the supporters. The canal's strategic importance as a military pathway was overrated, and the local states would receive most of the benefits. Therefore, they should expect to pay for it. The other, broader arguments noted that, eventually, private funding would complete the canal and that it was unconstitutional for the federal government to invest in a private stock subscription. Another attempt was made in front of Congress with a December 1823 petition that was updated in March 1824. That led to the introduction of a House bill that was debated in May. The bill barely passed for a third reading despite

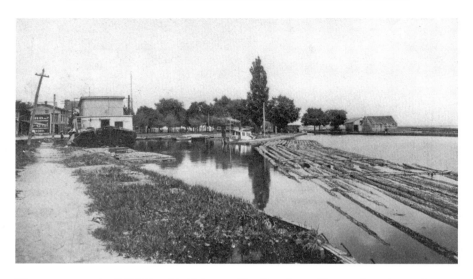

The entrance to the C&D Canal in Delaware City. Vessels would come from the north, either down the Delaware River from Philadelphia or from New York and New England, and enter the canal to reach the port of Baltimore or to meet freight in Havre de Grace, Maryland. The canal reduced the trip to Baltimore by more than three hundred miles.

passionate pleas from Representative Joseph Hemphill of Pennsylvania. The major opponents were from South Carolina, New York and New Jersey. James Hamilton of South Carolina said that the military importance was greatly overrated and suggested that private money would soon be found.

He was answered by Delaware's representative, Louis McLane, who suggested that Delaware, Maryland and Pennsylvania had already committed themselves to major internal improvements and could hardly be expected to fund such a nationwide undertaking as the canal. His speech was seconded by Samuel Breck of Pennsylvania, who strongly suggested that local sources had contributed $700,000 but would not be able to support additional funding.

The House bill passed, 113 to 74, and the Senate followed suit after a brief debate. President Monroe signed the bill into law on March 3, 1825. The federal government, recognizing the efforts on a local basis, pledged $300,000 to the effort. This 1825 pledge was followed four years later with another $150,000. The federal government had decided that investing in private ventures made sense if the project was deemed "too big to fail." The canal had the funding necessary to complete it after a nineteen-year wait.

The board of directors had taken the success of Mathew Carey's fundraising efforts to heart and decided to begin work on the canal prior to

receiving the pledge from the federal government. They hired the well-known engineer Benjamin Wright to be chief engineer in the winter of 1822–23. Wright was a graduate of the Erie Canal School of Engineering and had earned his reputation by supervising the building of the central sections of that project. Also hired as chief surveyor was another New Yorker, John Randel Jr. He would prove to be a critical hire. Two years later, he would file a lawsuit for breech of contract that, when resolved, put the canal company in financial distress from which it never recovered.

Randel had first appeared in 1805 during surveys for the Albany turnpike, and his reputation had increased enough by 1812 that he was known nationally. He had declined a position with the Erie Canal but had drawn up plans for a ship's canal across New Jersey and another in the Albany area. Later in life, Randel founded and became the proprietor of Randelia, a section of land located near Bohemia Manor. There he became known for his eccentric behavior and produced numerous tracts calling for various utopian plans. The most ambitious was the city of Morrisania, to be located north of New York City, that would feature streets two hundred feet wide in order to plant "trees and tasteful shrubbery." His favorite pastime became the filing of numerous lawsuits, of which his canal company suit was the most successful. Ironically, despite the problems associated with his hiring and subsequent firing, his route ended up being the one finally chosen for the canal.

As soon as he was hired, Randel immediately set out to resurvey the various routes that had been in contention years before, primarily the upper and the more southern/lower route. He concluded, despite strong objections, that the lower route should be the one. He dismissed the problems with cutting through the eighty-foot ridge that crosses the peninsula on the northern neck. (This so-called deep cut is still visible along the canal's north shore near the entrance to the modern Summit North Marina. It is just west of the railroad bridge and reachable by Lum's Pond State Park.)

Randel felt that a safe supply of water was more easily obtained with the southern route. There would be no need for a feeder canal to supply water. The eastern end at Newbolt's Landing featured deep-water access instead of the narrow, winding creek that the upper route used. The western end had not changed. It would be located on Back Creek, a tributary of the Elk River that empties into the Chesapeake Bay. Randel said that the lower canal could be built for $1.2 million. That was more than the upper route would cost but would strategically be a better choice. Randel overlooked the spongy soil of the eastern marshes, which would add $1 million to the cost of the project.

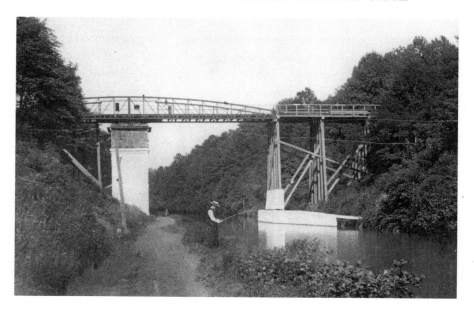

A view of the deep cut along with the Buck Bridge/Summit Bridge. This stretch of ground proved to be the most difficult to build and maintain due to constant floods and landslides. It was not until the canal was widened in the 1920s, using modern engineering techniques, that the problem was solved.

Randel's advocacy of the lower route was controversial. Delawareans wanted the upper route, which would end in Wilmington, chosen because of the financial benefit it would generate. Wright asked the secretary of war to supply engineers from the Army Corps of Engineers to resurvey the choices. Four engineers were assigned. They, along with Wright, a four-man board of engineers and the chief engineer of Pennsylvania, met to review the results in January 1823. Their choice was the more costly lower route. The residents of Delaware and Wilmington were not pleased and said that the selection was one of pure politics that ignored engineering and commercial realities.

The board of directors contributed to the firestorm of criticism by not releasing the reasons for the choice of the lower route until June 1824. They wrote in that report that there had been five major reasons for the choice. Deep water was available at the Delaware end, where a small harbor could be constructed to allow ships to wait safely for canal passage. Tides in a wide basin would be less of an issue. The fact that no aqueducts or tunnels would need to be constructed was considered, as well as the fact that a smaller number of locks would be needed. Finally, Fort Delaware, which had been recently finished, meant that security was no longer an issue.

1825: A Pivotal Year

The canal would be 13.6 miles long and rise 17.6 feet above sea level. Four locks (two tidal and two lift locks), 100 by 22 feet, would be built. The eastern entrance would be 46 miles from Philadelphia at Newbold's Landing (soon to be renamed Delaware City), and the western end would be on the always-reliable Back Creek on the Elk River. Ships could then freely sail down the Chesapeake Bay to Baltimore and beyond. The dimensions of the prism-shaped canal came to be 10 feet deep, 66 feet wide at the top and 36 feet wide at the bottom. There would be passing lanes every 0.5 miles except at the cut, where they would be 1 mile apart. The water supply was thought to be more than adequate, and the original idea of a feeder canal was abandoned.

Work began almost immediately, despite the fact that subscriptions had only reached $700,000 of the required $1.2 million, and by June 1824 there were 850 men and 150 horses at the site. The force grew to more than 2,600 men by the summer of 1826, due to the funds made available by Congress. The June 1825 report to the shareholders noted that the Delaware tide locks had been completed, the western one would be finished before winter, the artificial harbor had been built and work was progressing on the cut through the ridge.

The areas that needed attention were the eastern marshes, where the soil was proving to be difficult to deal with. The spongy soil would not support the canal walls, and the water was much deeper than originally believed. The crews would build a wall and return the next day to find that it had sunk back into the spongy land. In some locations, as much as sixty feet of soil had to be removed from the cut and placed in the marshes.

The contractor for the eastern end of the canal was the company's former chief surveyor, John Randel Jr. He had resigned his position and taken on the task of building the canal, but his personality immediately caused problems. He insisted on hiring New York (instead of Delaware) labor, making many local people angry and ready for a fight. Randel was also upset that Benjamin Wright had been chosen as chief engineer. That slight in Randel's eyes created an almost violent rift between the two men.

Wright, in his role as chief engineer, had the final say on what the contractors should be paid, and he could change the amount as he deemed fit. He immediately lowered Randel's compensation to $636 per month when Randel's subcontracts were costing him more than $2,500 a month. Wright also was expected to certify that the contractors' work was on schedule. Randel had a workforce of 514 men and 154 horses working in June 1825, but in late July, Wright evoked his privilege and suspended Randel's contract.

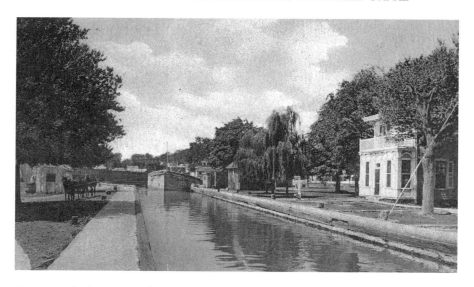

A postcard depicting a canalboat entering the locks at Delaware City. The team of mules is on the left side of the canal.

The board supported Wright's decision in September and Randel filed suit. He would eventually be rewarded more than $226,000.

Randel had an unlikely supporter in Mathew Carey. The fiery Irishman took up his cause both publicly and privately. He constantly tried to pressure the board into reconsidering Randel's firing. Carey believed that Wright had conspired to reduce Randel's compensation since the beginning and forcefully set the rates at less than the contractors cost because Randel had found out that Wright had extended the Erie Canal nineteen miles longer than required, producing $300,000 in revenue for himself. He also said that Wright purposely delayed certifying the work that Randel had done in order to deprive him of capital. Carey maintained that Randel had completed 43 percent of his section of the canal in just thirteen months, despite working through a harsh winter.

Wright publicly admitted animosity toward Randel, calling him "a complete, hypocritical, lying nincompoop," and stated that he knew his decisions were forcing Randel into debt and ultimately failure. Carey's efforts may have fallen on deaf ears, but Randel's were more serious. He went on to become chief engineer for several major projects while pursuing his lawsuit against the canal company, but his personality and reputation preceded him and inhibited his employment efforts. When he settled late in his life at his home near the Bohemia River, which he called Randelia,

he admitted that he could no longer find work as an engineer. His lawsuit wound through the courts until 1834, when he was awarded $226,000, a sum that the canal company did not have to waste. It would be one hundred years and a takeover from the federal government before it could recover from the financial blow.

Four contractors were hired to replace Randel. The board was so delighted with the initial results that it moved up the opening for the canal one year to March 1827, an optimism that would soon prove to be unfounded. Randel may have been gone, but the marshes still had to be dealt with. That problem, combined with yet another injunction from a contractor, conspired to further delay the finish. Work, though, was finally completed at both ends. The cut, an impressive site at 80 feet deep and 230 feet wide at the top, had been completed. A 247-foot bridge was built over the canal, which opened in October 1826.

Finances remained tight, and the company obtained a series of loans that allowed it to complete the work. The government took a subscription of another 750 shares so the company could pay the $28,000 in interest due on its various loans. Water was admitted along the entire length of the canal on July 4, 1829. The celebration would wait until October, but shipping along its length began almost immediately. Twenty-five years after the first shovel of dirt had been moved, albeit in a vastly different location, the canal dream was complete.

THE EARLY YEARS OF A WORKING CANAL

The final price for the canal was $2,250,000, or a mere $165,000 per linear mile. It was an extraordinary figure, even given the difficulty with the cut through the ridge and the overall width and depth of the project. In contrast, the cost per mile of the Erie Canal was $19,000. The canals in Pennsylvania had cost on average $22,000 per mile and, in all of New England, only $13,000. The canal needed paying traffic immediately in order to survive. The company had borrowed $1,000,000, and a substantial amount of its stock was owned by the three local states and the federal government. The price per share had dropped from a par value of $200 to a price per share of about $60.

The canal company held a massive, and expensive, celebration in October 1829, complete with twenty-one-gun salutes and speakers. Preparations for the canal opening were made by the new canal superintendent, Caleb Newbold Jr. A slide blocked the deep cut several days before the opening but was cleared in time for traffic to pass end to end. Rides were provided through the canal on steamships and rafts. Many dignitaries, including President Andrew Jackson, were invited to attend the opening ceremony, and many, like Jackson, had to send regrets. But one man who would not miss the day was Joshua Gilpin. He had resigned his board position in 1824 but had remained a strong advocate. He was on the first boat to pass through the entire canal.

August was the first month during which tolls were collected. Before the two toll collectors were hired, one in Delaware City and one in Chesapeake

City, revenue totaled less than $10. Once the two collectors were hired with annual salaries of $750, toll receipts rose. By October more than $300 a week was being collected. (Four lock keepers were also hired at $20 a month. One was also responsible for the bridge at St. Georges.)

Rules had been written that determined the types of vessels that could pass through the canal and items such as speed limits and the amount of tolls that would be assessed for various freights. At first, 206 products were listed, with prices ranging from $0.01 per bushel of grain to $12.00 for a boatload of fresh fish. Casks of wine cost $1.25. Empty vessels paid $4.00 for transit, but there was no toll if it was a return trip of fewer than thirty days. Revenues depended on the toll collectors to accurately determine the freight and charge accordingly, a system that would prove to be ineffective. Ship captains lied and the toll collectors failed to double-check. Laws were passed in 1832 in Maryland, Delaware and Pennsylvania that outlined heavy fines for toll fraud, effectively ending the problem.

Freight vessels carried passenger traffic, and soon purpose-built passenger barges began using the canal. The Citizens Line, which ran steamboats on both the Delaware and Chesapeake Bays, instituted service on barges with exterior dimensions of twenty-one by ninety feet, just inside the maximum size allowed in the locks. They were pulled by five or six horses, and the trip through the canal would take about two hours. It made for an easy trip between Baltimore and Philadelphia.

A second line, the Union Line, instituted service in 1830. Competition between the two was fierce. The rate for the passenger barges was initially $20.00 per day, with no charge for waiting extra days because the canal was blocked. The canal company did not collect a toll from each passenger, but the passenger lines paid $0.25 per passenger on board. This pricing lasted a year. In 1831, the two lines negotiated annual rates of $8,000.00 for the first vessel and $5,000.00 for additional vessels with no separate passage fees. They were given permission to move at twice the allowed speed during transit.

Traffic was heavy. The canal had to close for a month in February 1830 and still collected $27,000 in tolls during the first fiscal year, which ended in June 1830. The weekly average was about 102 vessels passing through, resulting in seven-day revenues of about $1,500. More than eighteen thousand barrels of flour passed through in the three weeks following the reopening in late February 1830. There were daily shipments of whiskey, lumber, grain and iron, as well as people.

The first full calendar year of operation, 1830, produced revenues of $51,000. The next year, the figure grew to more than $68,000. It

immediately improved the financial fortunes of the surrounding towns. Chesapeake City and Delaware City went from sleepy villages to large communities. Philadelphia, Wilmington and Baltimore felt the impact of the increased trade. Transportation costs dropped dramatically. It was recognized that the canal was more than just an economic success but rather was a key ingredient to national security. The U.S. House of Representatives noted in 1831 that "the value of this noble improvement to the nation, as a link of the Atlantic canal along the sea coast, cannot be too highly appreciated." The members of the House had a different mindset when they were soon asked for more funding.

The canal company stock was still undersubscribed. The total funds collected, counting the government purchases, were $1.2 million, leaving the remaining $1 million secured by loans. Annual interest on the loans was $60,000. Company operations were very efficient, costing less than 0.5 percent of the total required annual funding. This included salaries for the president, superintendent, two toll collectors, four lock keepers and three bridge tenders. Regular expenses, such as oil for lights and minor repairs, totaled $8,000. The annual expenditure was about $12,000, but there were extraordinary items. Major repairs were estimated to run $154,000 during the first three years of operation. The banks of the canal kept caving in. Steamboats were prohibited, but damage came from the remaining allowed vessels. A $2,200 dredge had to be purchased. Locks leaked, creating the need for constant and expensive maintenance. A culvert placed under the eastern end became defective and blocked the free flow of water, flooding many of the surrounding homes and farms, creating an additional financial liability.

Water supply, primarily from St. Georges Creek, was a constant problem, causing the canal to shut down in particularly dry weather. A steam power pump, costing $15,000, was installed in Chesapeake City to lift the water from Back Creek. Two dams and reservoirs above the summit were purchased to add additional water, but the issue remained.

Back Creek, the tributary that ran from the canal's termination in Chesapeake City to the Elk River on the Chesapeake Bay, was difficult to navigate, with dozens of sharp twists and turns. Debris blocked the channel. Shallow water and constantly shifting bottom contours caused boats to run aground. Engineering studies noted that the problems of Back Creek were a serious impediment to safe and rapid navigation. Costs to fix the problem were estimated at another $50,000. The canal company was encouraged by the engineering reports and applied for the dollars to be allocated to fix Back

Creek under a general appropriations bill that was in front of Congress. President Andrew Jackson had a policy of never using federal funds to support the financing of internal improvements, and he vetoed the bill. He said there was to be no dollars for private and local undertakings until the national debt was retired. Back Creek would remain a problem until 1853.

The canal company would continue with severe financial problems, only delivering a dividend to stockholders in 11 of the next 116 years. Revenues grew to more than $90,000 in fiscal 1831 but then declined the next 4. The railroads had arrived in the form of the New Castle and Frenchtown, providing competition that further eroded revenues.

This was the moment, on top of all the other issues, when John Randel Jr. and his lawsuit came to the forefront.

TROUBLES

Maintenance issues continued to plague the canal through the 1830s as the canal company dealt with landslides, shallow water and equipment failures. It often had to be closed for extended periods of time while the problem was corrected. The canal flooded every spring. A vent had to be opened at the summit level to remove the excess water, but the dry summer months dropped the water levels in the canal below the navigable stage. The lock operation consumed millions of gallons of water. The reservoirs opened in 1829 often had to be drained. A steam pump was installed in Chesapeake City to lift water from Back Creek into the main canal, but the major water source remained St. Georges Creek at the eastern end.

The lock system and harbor at Delaware City required expensive maintenance. The company applied to the federal government for assistance in paying the estimated $20,000 but was once again turned down. The locks at Chesapeake City gave way in 1837 and closed the struggling canal for three weeks. An 1833 storm damaged the banks so severely that the canal had to be closed for ten days. Major landslides occurred in 1834, 1837 and 1839. The 1834 slide happened in the deep cut, was over one thousand feet long and reached back two hundred feet from the canal's banks. The depth was reduced by three or four feet, preventing many boats from passing. Men with shovels cleared away most of the damage. The company dredger, working almost full time, did the rest.

About the same time, a major break occurred at the point where the canal intersected Broad Creek. Water was lost through a 150-foot-wide

breach. Water levels dropped to as low as 3.5 feet, and 6 feet of water was restored within thirty days; the damage from the break consumed resources for the rest of the year. Revenues for the entire season dropped to $54,000. Toll collection went down to $47,000 the following year and $35,000 in 1836. The company directors wrote to the stockholders in the annual report, "The past year may emphatically be called the gloomy period of the company."

They had yet to see the worst. John Randel Jr. won his day in court in January 1834. He received a judgment against the canal company for $226,000, the largest award for unliquidated damages up to that point in the United States legal system. The constant costs of maintenance and the interest on various loans (the canal company, in a practice reminiscent of 2009, took out loans to pay interest on previous loans) made paying Randel's judgment highly unlikely. The case was sent to a higher court, in which the canal company lost and was ordered to settle with Randel. Instead, the company directors took the interesting, and unproductive, stance of ignoring the entire thing. They made no move to negotiate a payment plan with Randel and seemed to behave as if the problem would go away by itself if left unattended. Randel was not going away. He introduced additional lawsuits in Delaware.

The case gained national interest and is probably the most famous lawsuit in Delaware legal history. The canal retained former senator James Bayard, while Randel's attorney was John Clayton, who later became President Zachary Taylor's secretary of state. Bayard filed briefs with higher courts, but the company again decided to avoid the issue by stopping toll collection on the Delaware side, preventing Randel, at least in their minds, from attaching the revenues. The company owed so much money that it refused to consider Randel's judgment as having a priority over other creditors.

Randel fought back with the support of the State of Delaware. At one point, things were so bad that the canal company would not allow its president, Robert M. Lewis, to visit the eastern end of the canal for fear that he would be arrested. Randel also took the extraordinary step of setting up his own tollbooth in Delaware, again with the support of both New Castle County and the State of Delaware. Captains ended up paying twice, once at the western end with the company toll collectors and then with Randel at Delaware City. Captains who refused to pay were thrown into Delaware jails and had their vessels and cargoes seized. The company retained Robert Polk to post their bails and encouraged captains to pay their eastern tolls in Philadelphia.

The canal company went to the Delaware legislature for relief, taking the position that the States of Maryland, Delaware and Pennsylvania had created the waterway as a public highway and that any attempt to restrict access, which Randel was doing, was illegal and in violation of the charters issued by the three states. The company was allowed to seize a vessel that refused to pay the freight, but the captain would only be liable if the toll could not be covered by the sale of the cargo on the vessel.

While the various appeals wound through the courts to the U.S. Supreme Court, Randel continued his efforts with the Delaware and Maryland legislatures. One move, ultimately rejected, was to have a Delaware law passed that would allow him to sell the canal corporation to cover the debt. He continued other legal, and not so legal, avenues while claiming to be a ruined, powerless man. He was still collecting tolls at the Delaware end and had filed a suit in Maryland that would allow him to collect at the western end. The company retained future Supreme Court justice Roger B. Taney but lost once again. It was allowed to continue toll collections while the case went to appeals court but had to escrow the money in anticipation of settling with Randel. The Delaware Court of Errors and Appeals upheld the legality of Randel's actions in November 1835. The company went to the U.S. Supreme Court, which dismissed the action because the body lacked jurisdiction. There were no constitutional issues involved, and the nine justices felt that it was a simple case of garnishment.

Randel had been fighting the company for many years and had won every battle. He announced that he would continue to collect the eastern tolls until the entire judgment, plus interest, had been covered. In early 1836, the company folded its hand and agreed to settle with John Randel. An agreement to pay the claim in full was negotiated by the various attorneys, but Randel rejected it in March 1836, believing that the terms were not in his favor. Canal president Lewis worked out a suitable agreement that was signed in April 1836, pending the approval of the stockholders and the Delaware and Maryland legislatures. Randel demanded that special sessions be conducted so he could receive his long overdue funds. Maryland acted quickly, signing a bill into law in May that had the additional clauses that noted that the canal company could not exercise banking privileges and had to ensure that the canal was navigable for ships until the judgment was paid to Randel. Delaware's deliberations took longer due to the death of the sitting governor. His replacement, Charles Polk, given the $1,250,000 debt incurred by the canal, demanded

that the creditors be given seats on the board of directors to ensure that their interests were being managed. The board increased from nine to fourteen members.

The agreement drawn up provided for funding Randel's judgment and all other canal debts. Certificates of indebtedness were to be issued, drawing 6 percent interest and stating that all other debt was subordinate to Randel's. He was to be paid within five years. In total, the Loan Act of 1836, more commonly known as the Randel Loan, amounted to $1,593,184. It would be another eleven years before the company could issue its first dividend.

The financial problems were by no means solved by the loan. The Biddle panic, similar to the financial crises of 2008 and 2009, caused a tightening of credit. One of the canal's creditors, the Second National Bank of the United States, demanded additional security for its loans. It also sued to recover back interest payments. Fortunately, ship captains, who refused to use the canal during the prolonged court battles with Randel, began returning. Revenues rose to $67,000 in the fiscal year 1837–38. The next year saw an equal amount. The dollars were applied to the overdue maintenance needs. Bridges, locks, towpath, banks and drains were all repaired and brought up to working order. Iceboats were purchased to keep the canal running during the winter months. The steam pump did a lot to ensure an adequate water supply all year. The company hired a Philadelphia professor, A.D. Bache, to make investigative trips to observe the European canals and report back any innovations that could be applied to the C&D Canal.

The Chesapeake and Delaware Canal was slowly becoming a functioning organization that could successfully run its operations and pay the stockholders, but several more controversies, coupled with bad decisions, would continue to distract company officials.

PASSENGERS AND STEAM

The Chesapeake and Delaware Canal Company made two important decisions early in its operational years. The first, not allowing steam-powered vessels through the canal, was made to protect the fragile banks. The second was more far reaching. While passenger boats and barges were charged a toll, the canal company made no attempt to collect any money for each person on board. The first decision was easily rectified. The second resulted in another prolonged legal battle. It would be 1850 before Chief Justice Roger Taney would rule against the company's petition to charge passengers transiting the canal. Thousands of dollars of lost revenue resulted from a simple decision made in 1829 when the canal regulations were first published.

The prohibition against steam-powered boats was made in the first year of canal operation because the banks were constantly eroding from waves generated by boats moving too quickly through the water. The board had authorized an expensive project to stone the banks, but members also decided to ban all steamboats, rafts, floats, tows or arks. The next year, the rules were changed, and only steamboats were prohibited. Passenger service companies went to the board in June 1831 to have that rule changed. The steamship companies were concerned that the railroads would prove faster and more convenient to passengers and wanted the chance to compete. They pointed to a book, *Remarks on Navigation, Illustrative of the Advantages of the Use of Steam as a Moving Power on Canals*, as proof. The book's author, William Fairburn, reported that trials conducted in Europe proved that a vessel moving at ten

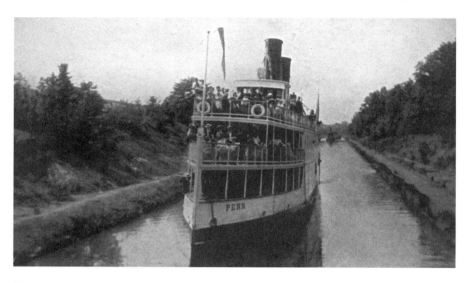

The steamship *Penn* is shown traveling through the deep cut, the section of the canal that required the most work, both initially and over the years of the canal's operation.

to twelve miles per hour did less damage than one moving at four to six miles per hour. He also pointed out that the use of steam would eliminate the expense of maintaining horses and mules to pull the traffic through, as well as the maintenance of the towpath the animals used.

The board of directors decided to investigate and purchased a steam-driven canalboat, with a reputation of being fast, at a cost of $1,200. It was eighty-eight feet long and twenty feet wide, with a paddle wheel on each side driven by an eight-horsepower motor. The president of the Union Line—a passenger company that ran steam-powered boats on the Delaware and Chesapeake Bays but used the New Castle and Frenchtown Railroad to transport its customers across the peninsula—expressed his unhappiness at the experiment by stating, "She [the canalboat] is an experiment merely & I think will fail."

The board of directors was pleased with the initial trial on the Schuylkill River in Philadelphia. The members saw that the use of steam would be a major movement forward in terms of speed and, therefore, the cost of transportation. Lower costs meant more freight and more canal revenue. The boat was moved to the C&D for further trials. The experiments were closely regulated in order to provide accurate data. They were observed by Professor A.D. Bache (who assisted the canal company in researching European canal innovations). He wrote that the wake from passenger barges

towed by horses was three times greater than that from the steam-powered boat; the paddle wheels dissipated the bow waves before they could reach shore. He felt that the trials "go far to remove, entirely, any doubts concerning the advantageous application of steam."

Despite the success of the trial, the company lacked the funds to introduce steam tows. The test boat was sold, and it would be the 1840s before steam-powered boats were common in the canal. Passenger travel was accomplished on barges pulled by horses. The trip could be completed in less than two hours if ten animals were used. This proved to be, at least temporally, a poor substitute for the railroad. The canal company had raised the rates to $10,000 annually for one daily trip of the canal, so the newly formed Citizens Line, originally the Union Line, moved all of its cross-Delmarva passengers to the railroad in 1832.

Competition arrived in 1833 with the creation of the People's Steam Navigation Company, which ran a new steamer, the *Ohio*, from Philadelphia to Delaware City. Passengers switched to what were described as elegant and commodious barges for the trip west, where they were met by the *Kentucky* for the trip down the Chesapeake to Baltimore. The Citizens-Union Line operated the steamers the *William Penn* and the *Robert Morris* on the Delaware and the *George Washington* and the *Charles Carroll* on the Chesapeake. It had negotiated an exclusive right to the railroad-steamboat option with the Delaware legislature and continued using the railroad, believing that the shorter travel time gave the company a competitive advantage. The People's line offered cheaper service. It advertised a more elegant trip, avoiding the railroads because of the need for constant stops due to blockages on the tracks. This spirit of competition pleased the administration of President Andrew Jackson, who abhorred monopolies.

Rate wars occurred almost immediately. The People's Line started at $3 per passenger, and the Citizens-Union Line immediately dropped its price to $2. Many believed that traffic was not heavy enough to justify the low rates and that the companies would drive themselves out of business. The Citizens-Union Line had no intention of using the canal. It was too invested in the railroad but offered to pay the canal company a minimum of $6,000 per year, with another $15,000 if no other company ferried passengers through the canal. People's tried running passengers across the peninsula in stagecoaches, but that mode of travel was outdated, at least in the East, by the mid-1830s. That, and the deal worked out between the canal company and the Citizens-Union Line, put People's out of business within two years. Once People's went out of business, the other line ceased paying the canal

company, though it did collect through a lawsuit a one-time payment of $15,000 in 1834. Regular passenger service would not resume on the canal until 1842.

A new steamboat company was formed in 1842 by two businessmen, but because of the recklessness of their passages, and the damage to the canal walls, they were soon banned. They could not use their steamers in the canal. Another company, the Baltimore and Philadelphia Steamboat Company, formed in August 1844 with the intention of hauling passengers on newer-designed boats with a shallow draft and the Ericsson screw, a new propeller created by a Swedish inventor, John Ericsson. This replaced the large paddle wheels of other steamers. Other lines soon followed, and each wanted special privileges to transit the canal, but the steamboats had to follow the same regulations as the towed barges or risk losing their opportunity to use the canal.

Toll revenues were increasing, even though the toll for each item of freight was declining. The canal company's early decision to not charge per individual passenger was coming back to haunt it. The company decided in 1843 to begin charging a toll on each passenger, again through a complicated arrangement with the railroad. The New Castle and Frenchtown Railroad agreed to charge not less than fifty cents per hundred pounds of freight if the canal would charge 50 percent of the rail fare for crossing Delmarva. Two weeks later, the railroad announced steamboat passenger service through the canal but at departure times so inconvenient that the canal company could expect no revenue. The canal company backed out of the deal the following year.

The canal company insisted on a per-passenger toll, so the right to do so was challenged in 1844 by another start-up. The new organization went to the Maryland state legislature. It was found that the canal had never been granted the right to charge passengers in its charter. The Maryland assembly corrected the mistake and stated that tolls could be collected as long as they were not more than twenty-five cents per person. It was necessary for both the stockholders and the Delaware state legislature to approve the change. Neither did within the required sixty days.

Delaware was receiving $10,000 a year from taxes paid by the newly formed Philadelphia, Wilmington and Baltimore Railroad, which replaced the New Castle and Frenchtown Line. The canal had never paid taxes to Delaware, so the state set out to protect its self-interest by refusing to act on Maryland's legislation. The governor, Edward W. Gilpin, threatened to revoke the canal company's charter if it continued to charge per passenger.

He stated that not only could the canal not charge for passengers, but it was also specifically prevented by its charter from carrying passengers other than the crew. The canal company informed the governor of its intention to reach a solution through the court system. It would still allow the transportation of passengers, although it would stop collecting the individual toll.

The canal company formally attended the next Delaware legislative session in January 1845 and applied to receive the same change in its charter that Maryland had granted to it. It claimed that it always was assumed that the canal would convey passengers, citing laws passed in Maryland and Pennsylvania during the War of 1812. Those laws contained a clause that stated, "During the time of war against the United States of America, by forming the great link of inland navigation of six or seven hundred miles, and thereby establishing a perfectly safe, easy, and rapid transportation of our armies and munitions of war, through the interior of the country."

The railroads weighed in with their view, and a battle between two major organizations was on. The canal put forth the argument that the waterway prevented the railroad from becoming a passenger monopoly. Many felt that both parties should be given the best opportunity for a return on the capital they had invested. The railroads reported that such an allowance would both jeopardize their revenues and reduce the income they paid to the State of Delaware. They claimed they had been granted monopoly rights in 1833. The canal company could not understand the logic of the railroad companies. Passengers had to pay to ride the railroad; would they not take the canal if it was free? Deliberations went on for three weeks. New Castle residents were for the change, but shippers from lower Delaware were against it, believing that family members riding freight barges would be charged as passengers.

No agreement could be reached. The canal company had submitted a bill that allowed for passenger tolls, changed the date of its annual meeting and offered to guarantee a loan to the railroad, which was having severe financial problems, from the state. A final argument was to be heard on the evening of January 22. Five days later, despite the spirited speeches by both sides, it was defeated. The legislature kept in the loan guarantee but noted that tolls could not be collected until 1856, when the railroad loan came due. The result was a toll battle, with both the railroad and canal reducing their rates for freight. The canal company had lost the ability to collect an important revenue source for the second time—the first by poor early decisions and the second by legislative fiat.

A barge under tow and a steamship travel in the canal under the glow of the moon. They are approaching Chesapeake City.

The debate did not end with the action of the Delaware legislation. John A. Perrine of Princeton asked for permission to operate passenger service in 1847. The canal company agreed, but it decided to test the validity of Delaware's bill by collecting a one-dollar-per-passenger toll. Perrine sued in a case that ended up at the Supreme Court as *Perrine v. the Chesapeake and Delaware Canal Company*. Three years later, Chief Justice Roger B. Taney ruled that while the company was prohibited from collecting passenger tolls, it did have the right to stop all passenger traffic. He ruled that the rights of a corporation are not superior to the rights of the public but that the pubic did not have a right to use the canal if the company refused service. The charter called for goods to be transported, not people. Both sides effectively lost, and the canal company never collected an individual passenger toll.

PREWAR UPS AND DOWNS

The twenty years before the Civil War were among the best, and the most frustrating, for the Chesapeake and Delaware Canal. It continued to suffer both maintenance and financial issues. Debt soared and had to be restructured several times, but total freight volume, and revenues, grew significantly despite the competition from the railroads and the lack of passenger revenue.

The opening of the Susquehanna and Tidewater Canal that ran along the Susquehanna River in 1840 did much to improve the traffic in the C&D Canal. The bulk of the freight, timber, grain, flour and various dry goods was moving eastward toward Philadelphia. Bacon, fish, groceries, molasses and gunpowder tended to move westward through the canal. DuPont, the leading manufacturer of gunpowder, was one of the larger shippers despite the fact that it used the sea route or moved across the peninsula in wagons for a significant portion of its shipping. The increase in traffic allowed the C&D Canal to increase its rates in 1846 and 1849 for all but sailboats and any boat originating at the Susquehanna and Tidewater Canal. The sailboat clause recognized that their lack of speed caused a competitive problem. The other was to protect the most valued traffic.

The company felt that improving towing services would expand the trade even further. A steam towboat company was proposed by the canal president in 1840 to move boats between Havre de Grace, located at the south end of the Susquehanna and Tidewater Canal and Chesapeake City, as well as from Delaware City, to Philadelphia. The canal company invested $1,000

in the new organization's stock. It began operations in 1841 and was an immediate success. It towed 961 boats in the first year and by 1847 was moving more than 4,800 vessels annually. As predicted, tolls per item were reduced but overall revenue increased.

The end of the decade saw more than half of the traffic in the C&D Canal originating in Havre de Grace, producing more than 25 percent of the canal's total revenue. The company managed to buy back five hundred shares of its own stock in 1843, paying only $5 for stock with a par value of $200. The shares remained depressed, selling for only $60 five years later, but its financial prospects were brightening. The toll revenue exceeded $100,000 a year in 1846, while operating expenses averaged about $31,000, producing a profit before interest payments of $87,000. A board committee recommended a 2.5 percent dividend on the interest due. The proposal was initially rejected by the full board of directors but was reconsidered, resulting in a 4 percent dividend to be paid in 1847.

A problem of interest on borrowed funds was not going to go away. The Randel debt of 1836 remained largely unfunded despite the fact that the five-year deadline to pay was closing. The balance of the 1836 debt also had to be dealt with. Interest charges had grown to $900,000. Arrangements were approved to once again borrow to pay the balances due to the creditors. A new debt was issued, but this time subscriptions were sold immediately, allowing the Randel debt to be retired by the middle of 1851. The Funded Debt of 1847 consolidated all current and previous debts into interest-bearing bonds that would come due in twenty years. The total of the new loan was more than $2.3 million, with annual interest charges of $143,000, but toll receipts allowed the company to meet its obligations for the first time.

The facilities needed to be improved. While the company dredger kept the water depth at a consistent six and a half feet, and a new 217-acre reservoir was constructed providing twenty-three feet of additional water, the company still lacked the funds to make major and required improvements. The locks needed to be rebuilt to accommodate newer, longer and wider boats. Bridges needed serious repairs. The company elected to go back to the federal government for funds for the project. Its timing was poor given the fact that the Mexican-American War had just begun. The appeal to Congress was made along military lines, stressing the need for the canal's ability to move men and material during the conflict.

The canal company officers presented their ideas to President Polk and his secretary of the treasury, Robert J. Walker. They suggested that by reducing the percent owned by the federal government by $450,000, private loans

Samuel V. Merrick

A portrait of Samuel Merrick, one of the engineers who designed and built the steam-powered lift pumps in Chesapeake City.

could be found for the lock expansions. In return for the stock reduction, no military vessel would be charged a toll. Secretary Walker agreed with their proposal since the government had yet to see a return on its stock investment. The bill went to the House of Representatives, where it was tabled for three years and then rejected.

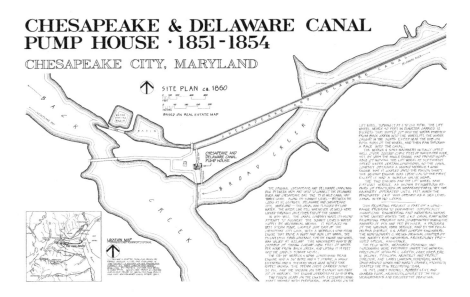

A site plan from 1851 that shows the location of the lift pump. Water was moved from Back and Broad Creeks into the main branch of the canal, supplying the locks with adequate water.

While maintenance issues were mitigated somewhat in the 1850s, it was obvious that continued improvements had to be made to accommodate larger boats and increased traffic. The old problem of water supply had to be dealt with. The board sponsored an engineering contest to find the best plan for a steam pump to raise the water levels at Chesapeake City. Fifty plans were submitted, with the winner being a design by Samuel Merrick and John Towne, both of Philadelphia, to build a steam-powered lifting scoop rather than a pump. Their plans, with a cost estimate of $22,000, were submitted in December 1849. The board waited to award the contract until members had inspected a similar lifting wheel at the United States Dry Docks in Brooklyn, New York.

The lift wheel was capable of lifting 200,000 cubic feet of water per hour while consuming fewer than 560 tons of coal per hour. The first trial of the newly installed, 150-horsepower engine and 39-foot wheel took place in April 1852. It raised an average of 227,000 cubic feet of water while using 613 pounds of coal per hour, slightly above expectations. The engine ran at twenty-four revolutions per minute. Engineers were concerned about the durability of the wheel and lift scoop. It was recommended that a second

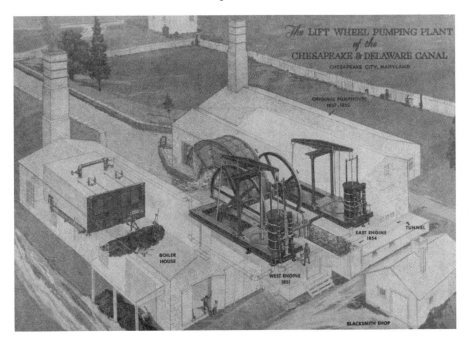

A line drawing of the pump house and machinery involved in the lifting system.

engine working at right angles to the first be installed in 1854. The water wheel was also replaced. The fixes allowed fewer revolutions while increasing the water lift. The wheel and steam engines remained in operation until the canal was converted to a sea level canal and are still installed as part of the Chesapeake and Delaware Canal Museum in Chesapeake City.

The canal's occasional lawyer was appointed president in 1853. His first act was to supervise the expansion of the locks. They were to be 220 feet long and 24 feet wide in order to be able to handle the newer, larger boats. The canal company again went to the federal government for funds for the locks in 1854. Secretary of the Treasury James Guthrie pointed out that the cost of the canal had now grown to more than $4 million and that the upcoming dividend was in jeopardy. The government's $450,000 investment had produced a paltry return of $13,500. The canal's petition was rejected again, and the company went in search of private financing. The board approved another $500,000 in loans, which eventually paid $87 per $100 in face value. It barely covered the total cost of the lock project.

The engineer in charge recommended using only three locks, not the four currently in use, reducing maintenance costs, water usage and travel times. Four bids were received for the project, ranging in cost from $171,000 to

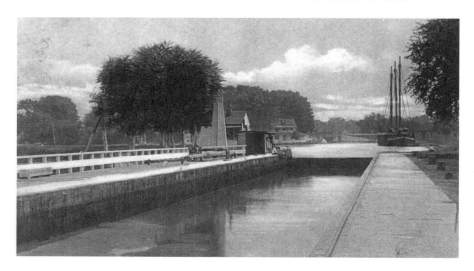

Above: An early view of the locks at Chesapeake City. The boat that waits in the background looks to be a Chesapeake Bay bugeye.

Below: The *Lord Baltimore*, one of the Ericsson Line's premier steam-driven passenger vessels, enters the canal at Delaware City. This street with the hotel behind the trees looks much the same today.

$280,000. It had been estimated that the lock project would cost $210,000, so the highest bid was rejected. The lowest bid was judged as suspect by the board because the contractor was an unknown, but ultimately the contract

went to that low bidder, the firm of Candee, Dodge and Reed. The firm completed the locks in June 1854, but costs had risen from the initial bid of $170,000 to more than $350,000.

The new locks and steam lift did not eliminate other maintenance issues. Large quantities of earth and mud had to be constantly removed from the

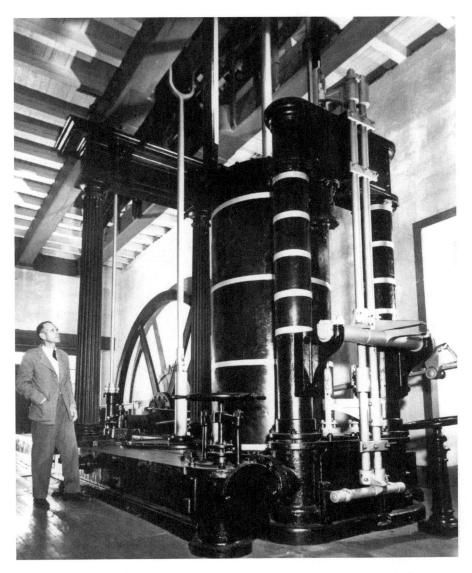

An image taken much later of the lift pump machinery that is still in place inside the C&D Canal Museum.

canal to keep it navigable. Bridges were caving in and had to be rebuilt or replaced. The harbors at both Delaware City and Chesapeake City were in constant danger of shoaling. The dredgers worked almost continuously, but the use of the canal continued to expand.

The total canal mileage in the United States in the 1850s was more than three thousand miles. They carried some six thousand tons per mile, or an annual total of eighteen million tons, producing annual receipts of $1,180,000. The railroads by contrast did almost eleven million tons of freight but produced only $1,081,500. Several canals produced their largest annual revenues in that decade.

The C&D Canal was not an exception to this increased use of canals. Revenues and profits grew each year despite competition and reduced tolls. Coal shipments alone increased six times from the twenty thousand tons shipped in 1849. Tows through the canal grew from 3,700 in 1849 to more than 5,500 in 1857. The canal was as financially secure as it had ever been, with freight tonnage, revenues and profits increasing every year. The fortunes of the canal were about to make another upswing with the unfortunate arrival of the Civil War.

WAR COMES TO THE CANAL

The cultural and political boundary that the Chesapeake and Delaware marked was never more evident than during the Civil War. Pennsylvania was firmly pro-Union. Delaware and Maryland were considered neutral or border states, but while the upper reaches of both sided with the Union, the lower portions were definitely sympathetic with the Confederacy. The only reason that Maryland maintained its neutrality was that the governor, Thomas H. Hicks, refused to convene the legislature in April 1861; otherwise Maryland would have followed the lead of neighboring Virginia and seceded from the Union. As General Bradley Johnson, a Marylander who joined the Confederate army, later wrote, "Maryland's heart was with the Confederacy, but her body was bound and manacled to Union."

Washington, D.C., was surrounded by either Confederate states or populations with strong Southern loyalty. Baltimore was a prime example. President Lincoln needed more troops to protect the capital from possible invasion. His call brought volunteers from Massachusetts and Pennsylvania. At that time there was no through train service in Baltimore, and passengers needed to exit one train and walk several city blocks to another station. The Union troops marching between trains were met with angry pro-Southern mobs who threw rocks and fired weapons. The soldiers returned fire, resulting in multiple deaths among the soldiers and the rioters.

Governor Hicks and Baltimore's mayor, George W. Brown, asked the president to refrain from sending more Union regiments through the city. Lincoln ignored the request and threatened more armed troops who

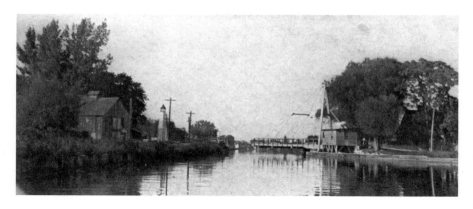

The original pivot bridge in Delaware City. The A-frame on the right lifted one end of the bridge and swung it against the opposite shoreline to let vessels pass.

would fight to take the city back from the rioters. Brown and Baltimore's police marshal decided to destroy the railroad bridges on the Philadelphia, Wilmington and Baltimore Railroad, as well as those on the North Central. Hicks later denied that he approved of the plan, but other officials were with the parties who headed north to the bridge across the Gunpowder. They set fire to the structure and cut the telegraph wires. The Union troops making their way toward Washington, D.C., were forced to retreat to Wilmington.

That left water as the only viable means of transportation for large groups of men and equipment. The Confederates held the Chesapeake Bay almost to Annapolis, and their raiders were seizing Union ships that attempted to round the Delmarva Peninsula. The canal was protected from the Confederates and allowed Union forces to be moved quickly down the Chesapeake. The Federal government seized all the steamships in Philadelphia on April 20, 1861. Some sailed empty through the canal and met the Union army in Perryville, Maryland. Others moved fully loaded through the C&D. The Indiana militia rode a train eight hundred miles from Indianapolis to Trenton, New Jersey, in order to meet a ferry barge; 14 steam vessels transported four regiments along with their heavy artillery from there to Annapolis in twenty-eight hours, where they could march overland to defend Washington, D.C. The early advocates of the canal as being of great military value were being vindicated. Ultimately, 144 propeller-driven steamboats, 89 tugs and 842 freight barges would be commandeered during the war. These vessels moved Union regiments, guns, ammunition, clothing, medical supplies and other war items from Philadelphia westward through the canal. Confederate prisoners were sent east to Fort Delaware. Wounded soldiers were sent to Northern hospitals through the canal. Government vessels could pass through the canal without paying a

War Comes to the Canal

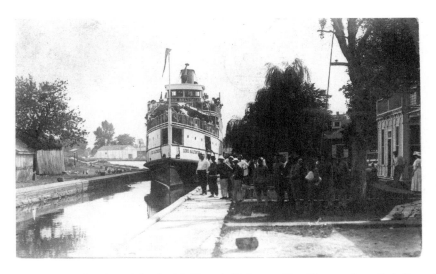

Passengers wait to board the *Lord Baltimore* in Delaware City. The canal saw little financial gain from the thousands of passengers who traveled the waterway on ships provided by Ericsson and other firms.

toll. Manifests were later presented for payment. Private boats working under contract with the Union government were given special rates.

There was a great deal of fear that the Confederate army would attempt an attack on the now strategically important canal. Two hundred more men were sent to Fort Delaware, and the Pennsylvania militia was ordered to patrol the canal. Company officials did not appear to be worried. They made small financial contributions toward the defense and took the step of building duplicate lock gates in case they were damaged, but overall their reaction was one of joy at the sudden increase in traffic and revenue. Freight averaged over 790,000 tons between 1862 and 1865, and the revenues in the fiscal year 1864–65 amounted to $424,000, both figures that the privately held canal company would never again achieve.

The Civil War made all the canals and railroads in the country extraordinarily profitable. The *American Railway Journal* reported that 1863 was the best year ever for the railroads. The Erie Canal saw a doubling of the number of boats using it between 1860 and 1863. The directors of the C&D Canal Company were confident that the "convenience of the Canal, as well as its capacity for doing larger business is now better known and appreciated by the public than ever before." The board predicted that trade would remain at a high level, but despite "a state of greater efficiency than at any former period" the company would face severe ups and downs over the balance of the nineteenth century.

POSTWAR BLUES

The Chesapeake and Delaware Canal Company Board of Directors was exuberant at the close of the Civil War. The board members had seen their shipping totals and revenues rise dramatically, and the trend was continuing. Tolls exceeded $300,000 each year of the decade, reaching more than $400,000 in 1870. The tonnage shipped rose from an average in the war years of 600,000 tons to more than 900,000 tons per year in the latter half of the 1860s.

The board felt confident enough in the canal's future to declare the first cash dividend since 1853. The shareholders were to be paid 3 percent in 1866. This annual dividend was soon replaced by 3 percent to be paid semiannually in each of the next six years. A stock dividend was declared in 1866 and again in 1869. This increased the number of shares outstanding by 25 percent the first time and 30 percent three years later, but the par value of each share was reduced. Many of the outstanding shares had been held by the subscribers since 1803. Even more were initially purchased in 1823. By 1876, the last year a dividend would be paid, shareholders had received $120 in cash dividends for each $200 share originally subscribed to and a 52.5 percent increase in the number of shares they held. The funded debt had also been reduced in the late 1860s by $640,000, saving $38,000 in interest charges. Revenues were strong enough that by 1872 the debt had been further reduced from the original $2.8 million to $1.9 million.

The canal was in its best shape. New bridges had been constructed, and the steam pumps had been rebuilt and were in good working order. Efforts

to secure the canal banks were finally producing results. New lock gates were constructed in 1871, and the locks at Chesapeake City were rebuilt shortly after, but three factors brought the postwar honeymoon to an end. Shipping costs began to drop dramatically, resulting in reduced revenues. The canal would suffer its most expensive accident in 1873, and to add to the competitive pressures, a movement to create a competing sea level shipping canal across the Delmarva Peninsula was introduced in Congress.

Total tonnage sent through the canal reached one million annually in 1869, a rate that was sustained for the next several years. After a slight decline in the last few years of the 1870s, tonnage increased again in the early 1880s. About 80 percent of the traffic was eastbound. Popular items being shipped included lumber, timber, grain, coal, flour, groceries, dry goods, oysters and iron. The volume shipped may have stayed relatively steady, but the toll charged per ton continued to drop, going from an average of forty-eight cents in 1865 to less than eighteen cents in 1885. The competition came not only from the railroad but from changes in the market as well. The timber stands of Pennsylvania were nearly exhausted, reducing lumber shipments. Wheat could be more cheaply transported from the newer, western states via railroad. Many food products, such as peaches, were no longer grown locally.

An increasing amount of coal was being shipped by rail. Shipments averaged 500,000 tons a year between 1865 and 1875 but dropped to an average of 377 tons per year by 1877. The shipping charge per ton dropped from sixty cents per ton in the 1850s to twenty-seven cents in 1870. It was down to nine cents by the early 1880s.

The canal, in order to keep shipments steady, resorted to rebates. Any party that shipped more than 50,000 tons of coal through the canal in 1866 would receive five cents per ton back from the original twenty-cent-per-ton toll. The coal coming from Pennsylvania's Wyoming Valley was particularly vulnerable to railroad competition and, as a result, was priced at fifteen cents per ton. The Delaware and Chesapeake Towing Company, the replacement for the original company, the Philadelphia and Havre de Grace Towing Company, was to receive a $1,500 bonus if it hauled 100,000 tons through the canal; 200,000 tons would earn a $2,500 bonus.

Finances were not helped in 1873 when the worst disaster in the canal's short history occurred. It was actually composed of two events, happening days apart, that resulted from a weeklong rainstorm that began on August 12, flooding the canal and damaging the banks and towpath. Barges and ships were held at either end for several days while the canal was repaired. Shipping was reopened just in time for the

heaviest rain. This time not only the canal but also the ships within it were damaged. The rain washed the banks into the canal, taking the towpath with it. The water depth of the canal was reduced by several feet by the hundreds of tons of sand, gravel and mud that slid into the canal. The waves from the landslide tossed the boats in the canal out of the channel and up onto the banks. Some of the vessels were washed as much as three hundred yards out of the canal.

Then a second disaster hit when the banks holding the largest reservoir gave way, putting more mud into the canal. More significantly, the major source of water to refill the canal after the repairs had been made was destroyed. The abutment supporting the Delaware Railroad Bridge was also washed away. It was estimated that it would take sixty days and up to $600,000 to reopen the canal, but the superintendent, John R. Price, managed to reopen it for vessels with less than eight feet of draft within a month. Grounded barges and ships had to be removed before full operations were resumed in mid-October. The final cost was $92,000, not including an estimated $40,000 loss of revenue.

The canal managed to carry 1,258,732 tons of freight in 1873 despite the closure, but a business downturn occurred the same year, driving down the price per ton. Shipments began declining at a higher rate and by 1880 were less than half of what they had been in 1873. The company invested $10,000 in a new transportation company, the Chesapeake, Delaware and Hudson Line, in the early part of the decade, hoping to improve shipments, but the company failed after nine years. The C&D Canal Company received only a $1,100 return on its investment. Canal employees were forced to take pay cuts.

The company also had to face a possible new competitor—another canal to be built across the Delmarva Peninsula. Ironically, many supporters of a new, wider and deeper canal were using national defense as the reason. This one was proposed as a sea level canal. The sea level Suez Canal was being built, and a similar canal across Central America was gaining support. The lack of locks would allow for larger ships and quicker transits. Congress was petitioned to support new surveys to find the perfect location. The House of Representatives called on the secretary of war to supply it with complete information on a new canal between the Chesapeake Bay and the Atlantic Ocean. Major William Craighill of the Army Corps of Engineers was assigned the project but said that he could not completely answer the questions posed by the House until extensive surveys had been made. He asked for an appropriation of $20,000.

Congress passed the Rivers and Harbors Act in 1878, which authorized the Army Corps of Engineers, specifically Major Craighill, to undertake extensive surveys to determine the feasibility and costs of a new canal. It would be lock-free, twenty-six feet deep and one hundred feet wide at the bottom. There were six possible routes considered. Interests in Baltimore, who wanted a canal closer to their port, pressured Craighill to ignore the possibilities of expanding the existing canal.

He submitted his final report in November 1879. He used the estimate of time and mileage between Baltimore and a point twelve miles off the Delaware coast as a method of comparison. A transit outside around the peninsula would be 325 miles and take almost thirty-four hours. The most northern route suggested would be a total trip of 129.5 miles and would take fifteen hours from Baltimore to the twelve-mile point. The most southern route, which would use the Choptank River, would be almost 150 miles and take just under twenty hours. The other four routes considered used the Wye River and several tributaries of the Chester River. The delays caused by winter ice were studied, as well as the need for dredging deep-water access across the Chesapeake and against the natural tidal flow.

Further pressure was applied when Maryland—and then, a year later, Delaware—chartered the Maryland and Delaware Ship Canal Company. This move was in addition to the efforts being conducted at the federal level. The C&D Canal Company was forced to hire expensive legal council to protect its interest and to remind the state legislatures that this step would cut their own financial throats since they owned stock in the current company. The advice was ignored and five surveys were authorized.

The only suggested route north of Baltimore was one that used the Sassafras River, located just ten miles south of the current canal. It was estimated that an eighty-foot-wide, fifteen-foot-deep canal using this route would cost $8 million. The cost would rise to $12 million if the size was expanded to twenty-five feet deep and one hundred feet wide. The new company began obtaining options to the land along the proposed route.

Craighill amended his report to Congress in 1880, stating that the cost of using the Sassafras would be $8.5 million, but he also suggested that if the northern route, preferred by many, was chosen, a serious review of expanding the existing canal be conducted, since the United States had already invested $500,000. These reports were submitted to the Congressional Committee on Transportation Routes to the Seaboard. The committee recommended that additional routes be considered and strongly felt the need for a new

canal across the Delmarva Peninsula. The committee promptly authorized $10,000 for more surveys.

Captain Thomas Turtle was assigned the survey of 1881, but before work could begin, Congress authorized another $10,000 under the Rivers and Harbors Act. It specifically asked that the surveys answer the questions of which route would afford the greatest protection in times of war and which would most significantly lower the cost of transporting goods. It also asked for cost estimates but was careful to state that these questions were not committing the government to any actual construction.

Turtle's report gave the estimated construction costs for three routes. The Choptank route, the longest, would cost more than $18 million. The Sassafras route would cost $11 million, but rebuilding the existing canal would only be $7.5 million after the costs of purchasing the canal. He felt the current canal afforded the best security but that winter ice would be a problem. As a result, Turtle figured the annual maintenance costs to be the highest ($123,000) on the current canal, while the costs on the Choptank and Sassafras would be $111,000 and $114,000, respectively.

The report strongly recommended a special commission to discover and suggest which routes best met the criteria set forth in the Rivers and Harbors Act emphasizing the dual goals of defense and economical commerce. The commission would consist of experts but would feature input from non-

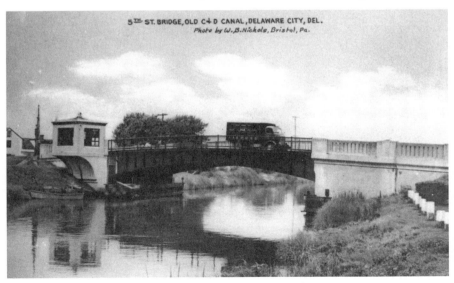

A delivery truck crosses the bridge over the branch canal in Delaware City. The bridge, after a number of modernizations, is still in operation.

engineers representing the interests of Baltimore and the western states. The members would also study the viability of the federal government taking total responsibility for a new, sea level canal. The idea of a special commission was supported by the secretary of war, Robert T. Lincoln, but it would be more than a decade before it was acted on. It would be some comfort to William Craighill and the other commission advocates that they put into motion the idea that the federal government should take over the current canal.

The Chesapeake and Delaware Canal had survived both its worst disaster and largest competitive threat, but problems would continue into the last two decades of the nineteenth century.

POLITICS AND THEFT

The 1880s

The beginning of the end of a privately financed canal came on June 30, 1886. The canal company had spent most of the last two years trying to refinance the loans of 1856. It had experienced net revenues of $58,000 during 1885 and 1886 and felt that the time was right for rolling over the $1.9 million debt still outstanding. A new thirty-year loan was proposed, offering an interest rate of 5 percent that would be secured by the property valued at $3.9 million.

The trouble was that actual debt was $650,000 more than the company officials realized because the president, Joseph E. Gillingham, confessed to issuing fraudulent bonds worth $600,000 and helping himself to more than $50,000 in cash while he was secretary-treasurer of the company. The fraud extended back to 1862. He announced his illegal activity in a letter he read to the board one day before the refinancing of the 1856 loan would take place. In his confession, he stated "having hoped against hope still to cover my crime by misrepresenting the amount extended until they stopped the extension. Then there is no hope for me and I began to prepare for a living death with all the nerve I was master of." He promptly fled to Canada.

The canal had continued to boost annual freight tonnage during the 1880s, but the growth in revenues averaged only $191,000 a year and failed to match the increase in shipments. Daily operating expenses remained low, with the canal in good working order, but the banks had to be repaired in order to maintain sufficient water for the new, larger barges to pass. A new bridge was built at Summit in 1883, and a fire

destroyed the building housing the pumping station at Chesapeake City, but the machinery itself was not damaged.

The major reason for the loss in revenue was a failure to increase tolls to keep pace with costs. The toll committee analyzed the toll structure in the winter of 1883–84 and came to the conclusion that the tolls collected were at a rate below what it cost the company. Coal was the worst offender. The Pennsylvania Railroad's freight agent suggested that both companies raise tolls on all goods. Coal transportation was increased from $0.07 to $0.20. The company went from a $20,000.00 deficit in 1883 to a $29,000.00 profit in 1884.

The Ericsson Line dominated steam traffic through the canal, while most other traffic was pulled by the traditional teams of mules walking the towpath. Thousands of sailboats and barges were pulled through by teams supplied mostly by Brady and Sons of Delaware City. Four animals were used on large tows, but some smaller boats could be efficiently pulled by three mules. A five-mule tow would be used if the captain of the vessel paid more. Their barge could make the transit in as few as five hours. The mule company had stables with sleeping quarters for the drivers at both ends of the canal. The towpath ran along the canal's north shore. When two boats met, one would lower its towline beneath the surface of the water to allow the other boat to pass. Drivers received twenty-one dollars per month and the use of the living quarters above each stable.

Mules pulled tows as late as 1906, but their charm was being replaced by steam power. A virtual monopoly was held by the Baltimore and Philadelphia Steamboat Company, otherwise known as the Ericsson Line. In 1885, $69,000 of the $200,000 annual revenue had come from this one source. The company realized that the steam companies, Ericsson and others, were depriving the C&D of an important revenue source. The Ericsson Line was paying a 10 percent toll on all of its freight shipped on an annual basis. It was raised in 1884 to 15 percent when all tolls were increased. Other steam companies paid the normal tolls on the type of freight they carried, plus a 50 percent surcharge.

The issue would become one of the largest internal political battles in the history of the canal company, with half of the board more interested in protecting the revenue of the Ericsson Line than that of the canal company. It was proposed in 1877 that a committee be appointed to investigate the company getting into the transportation business. Despite heavy opposition from some members of the board, an application was made to the Delaware General Assembly to alter the charter. The bill, authorizing the canal

company to "enjoy transportation powers and for that purpose hold, use, possess and own steam and sail vessels, barges, and other craft" was approved in February 1877.

The company failed to act on its new powers. A resolution was introduced in 1880 that urged the board to immediately consider "using its authority to own and operate vessels to obtain for the canal its natural and fair proportion of the trade and travel of the country." The resolution was supported by the fact that the company had failed to earn a profit since 1876, making the investors desperate for new revenue sources. The company president asked for a $200,000 loan to build two iron steamers. The board deliberated for several months and then rejected the request. Several stockholders were convinced that board members' interests fell more in the Ericsson camp than in protecting the canal. They demanded, and gained, seats on the board. They immediately approved a resolution that authorized board member John Haug, a marine engineer by trade, to draw up plans for a steamboat. The drawings were presented, but again the subject was tabled by the larger board. The vote was six to six, with President Gray voting against the resolution.

A proxy fight over voting shares consumed most of the next three years. (The value of the stock had sunk low enough that its only real value was the voting rights.) The result was that the board members supporting the canal company expanding into the transportation business were voted out of office in 1883. The company's secretary-treasurer, Henry V. Lesley, who later would be found guilty of embezzlement along with Gillingham, was forced out of office for supporting the transportation idea. He made the mistake of pointing out that the company's bonds, selling at seventy dollars, had risen to ninety-two dollars when it was believed that the company would expand its business to compete with Ericsson.

The board of directors appointed a committee to investigate the charges that certain members had a conflicting relationship with the Ericsson Line. They also requested that President Gray express his views on the subject. He said, "I know of no contracts, written, verbal, or implied, between the Ericsson Company and the Canal Company, giving them exclusive rights." He emphasized that the company had no powers, under its charter, to make such a contract.

Gray's belief was that the canal was a free highway for all vessels carrying freight but that the use of steam was a right to be granted solely by the canal company. He felt that it was in the best interests of the canal to have one steam company carrying freight and "while it could not prevent competing lines in the canal, would not encourage such competing lines and would

manifest a policy not friendly to their establishment." He was unwilling for any company, either owned by the canal or otherwise, to establish a company competing with the Ericsson Line. The subject was closed when the company reported to the Interstate Commerce Commission that the canal company was not a common carrier but was simply the owner of the Chesapeake and Delaware Canal. A favorable pricing structure, along with the board's refusal to act on the proposal to investigate becoming a transportation company, solidified Ericsson's monopoly.

The canal company would never recover from the twin blows of once again purposely limiting its business model and the embezzlement conducted by two of its most trusted employees. Improvements necessary for the continued operation of the canal were underfunded because the amount of debt had increased to $2.6 million, with annual interest charges of $130,000. Revenues were averaging $147,000, leaving barely enough to pay the employees. The calls for a lock-free sea level canal, publicly owned and operated, only increased.

THE TURN OF THE CENTURY

The country's attitude toward canals after 1900 was 180 degrees from the attitude prior to the turn of the century. All canals, not just the C&D, suffered greatly in the last years of the nineteenth century. The best year for tonnage shipped for both the C&D as well as the Erie Canal was 1872. Traffic exceeded 1.3 million tons in the C&D's banner year but declined to fewer than 650,000 tons by 1900. The net revenues for the entire decade were $23,000. The major cause of the declines was the increased competition of the railroads. The Pennsylvania Railroad even went so far as to sign a 999-year lease with the Delaware and Raritan Canal across New Jersey with the sole purpose of driving it out of business.

Maintenance work suffered as a result of the declining revenues. The locks leaked badly, the banks were slipping into the canal itself, reducing the navigable depth to less than nine feet, and the bridges were badly in need of repair. The cost to fix all the problems was estimated to be $60,000. The decade-old problem of interest on the $2.6 million in debt was draining more funds.

The canal company was also reluctant to make many investments in its infrastructure because of the persistent rumors that a sea level ship canal would be built across the Delmarva Peninsula that would be funded entirely by the federal government. The company was doing everything in its power to make sure that its canal was selected, but powerful forces were pushing for other routes.

The attitude toward waterways and canals changed remarkably with the turn of the century. William Willoughby wrote in his 1961 study of waterways that "with the possible exception of the twenty-five years following the close

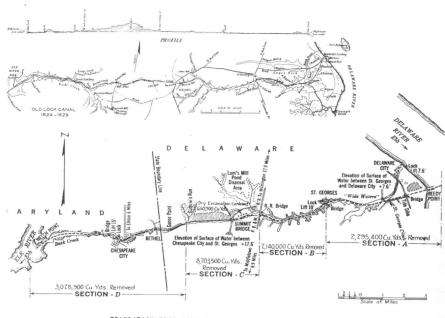

TRANSITION FROM LOCK CANAL TO 12 FT. SEA-LEVEL CANAL

An Army Corps of Engineer map that shows the transition from a lock to a sea level canal. The map shows the cubic feet of soil that had to be removed to accomplish this rebuilding, which included moving the east end of the canal from Delaware City to Reedy Point.

of the War of 1812, at no time in the history of the American people has interest in rivers and canals been quite so intense as during the first ten or fifteen years of the present century." There were dozens of commissions, associations, Congressional committees and presidential boards to study the issues of waterways and petition Congress for action, though ultimately only one would matter.

Much of the renewed interest was based on the recognition that waterways were of both strategic and commercial value to the United States. Some of the prime drivers behind this movement were the railroads, which had reached a late conclusion that competition from canals would be to their advantage. The railroads had laid 225,000 miles of track but were still unable to meet consumers' demands. Traffic congestion was so bad that a trip from Philadelphia to New York took a week or more. The railroads' natural speed advantage was all but eliminated. Experts on railroads estimated that it would take a $500 million investment in order for them to handle all the freight and passengers available to them.

The Turn of the Century

James J. Hill, one of the leading authorities on railroads, said in a speech in 1908 that "no intelligent railroad man feared waterways as a competitor, not because they were either unimportant or powerless, but because the two carriers are supplementary instead of mutually destructive." He called the canals helpers of the railroads. This was a far cry from the attitude of the previous century, which was to eliminate all competitive threats through predatory pricing and leases designed to bankrupt canal companies.

Two of the most influential organizations that were created in the interest of waterway growth were the Lakes-To-Deep Waterway Association, formed to promote connecting the Great Lakes to the Mississippi River by the Illinois River, and the broader National Rivers and Harbors Commission. Their main issue was soliciting Congress to pass a bill that would provide annual funding to the development of internal waterways. They proposed that Congress immediately earmark $50 million for the creation of a national waterways commission and the creation of a cabinet-level position of secretary of transportation, whose department would be responsible for controlling all waterways, highways and railroads. New York State was so sure of the future of canals that it committed $101 million to convert the Erie Canal into a modern barge canal.

President Theodore Roosevelt recognized a political movement when he saw one and appointed the Inland Waterways Commission in 1907. The nine-member committee would study the improvement and control of a national waterway. Its 1908 report called for, among other things, a complete study of the feasibility of the systematic improvement of inland waterways and the need to "encourage greater cooperation between rail and water carriers."

The Chesapeake and Delaware Canal Company used this frenzy of activity to actively promote itself as the natural choice for a sea level ship canal across Delmarva, but it also chose this time to reintroduce the age-old issue of charging a passenger toll. It ran into the same issues that had arisen twenty-five and fifty years before: the fact that the steamboat companies, primarily the Ericsson Line, had more power and they were obviously against the change. John Cadwalader, president of Ericsson and a board member of the canal company, publicly stated that the change would destroy the steamboat company. He showed little concern for the finances of the struggling canal company.

The company had applied to the State of Maryland for authorization and discovered that the state had already approved a passenger toll, not to exceed $0.375 per person, in 1846. The company was poised to now formally accept

the legislation and collect a toll in Maryland alone. The lawyers said that because the canal's charter was incorporated in three states—and because the Supreme Court case *Perrine v. the Chesapeake and Delaware Canal Company* had ruled against the company—one state alone could not authorize a passenger toll.

The company reapplied to Maryland. Representatives of the Ericsson Line testified at the hearing that the C&D was a bankrupt company whose application would destroy the steamboat company. It had lost $80,000 on moving freight the previous year but had made up for the loss with passenger revenues. The passengers could not afford two tolls, Ericsson's and one from the canal. The canal company argued that it would already be charging a passenger toll had it not been for a legislative oversight when the original charters were authorized.

The legal wrangling went on for several years and involved both the Delaware and Maryland legislatures, as well as scores of lawyers from both sides. The result: the canal company's efforts failed again and the canal remained toll-free to passengers.

The three-year battle destroyed what little relationship remained between the C&D Canal Company and the Ericsson Line. Cadwalader lost his board seat and the tariffs were renegotiated. Various flat rate schedules for passengers were agreed on and employed. It was remarked in one commission's 1908 report that the "long controversy between the managers of the canal company and the Ericsson Line had lasted as long as the canal company existed."

The company had other lawsuits with which to contend. One was an eight-year battle concerning its right to regulate towing. The other, a more serious suit, concerned Maryland's Blue Laws—the prohibition against working on Sunday. Forty-five people had been arrested on two successive Sundays in Chesapeake City, and a local magistrate fined each person five dollars and costs. The canal paid the fines, but the local government appealed, saying that it was the employee's responsibility to pay. A year later, the court found for the company, since by charter the canal was a public highway and expected to be operational at all times. Employees were given every other Sunday off, and pay was increased for working that day.

The biggest change for the C&D was taking place in Washington, D.C. President Roosevelt, in response to a joint resolution approved by Congress in June 1906, had appointed the three-man Inland Waterways Commission. Though it would be thirteen more years before its report took effect, the decisions it made and plans it suggested dictated the future of the C&D Canal.

A NEW VISION

The calls for a new sea level ship canal across the Delmarva Peninsula were first heard in 1871. Discussions on the subject ebbed and flowed over the next forty-eight years. There were innumerable conventions, committees, Congressional resolutions, independent advocacy groups and official task forces that were appointed, or at least were self-appointed, to conduct surveys and studies outlining the viability of various routes, as well as the costs, of building a deeper and wider canal. Congress passed a new Rivers and Harbors Act almost every year in the first two decades of the twentieth century, though it consistently failed to allocate money for the building of a cross-Delmarva canal or purchase of the C&D. The only two committees that were ultimately effective were the Agnus Commission, appointed by President Roosevelt, and an independent waterway advocacy group, the Atlantic Deeper Waterways Association. And in the middle of all the commissions, studies and surveys, the canal company was sued by the federal government.

The canal company, expecting to be bought any day, failed to invest in maintenance, but there was no guarantee that the C&D Canal would be chosen to be rebuilt as a lock-free ship canal. Baltimore was the largest problem, at least in the early years in the discussions about a ship canal. Influential interests there felt that the current C&D Canal was too far north, and too small, to handle the city's foreign trade. They preferred a southern route that would allow ships to exit the Patapsco River, which runs into Baltimore harbor, steam across the bay, up the Chester or Choptank River, through a canal and out into the Atlantic Ocean.

One of the early engineers stands outside his truck, which is parked in front of the frame house that still serves as the Army Corps of Engineers headquarters.

The canal company's board of directors spent most of its time lobbying for its selection through a committee, the Ship Channel Committee. It received support of a strange bedfellow, the Ericsson Line, which consistently wrote that its use of the canal had been economically favorable and that it believed that a large canal at the same site would be of significant commercial and strategic advantage.

The first surveys conducted in support of a new canal were conducted in the late 1870s by a group of engineers led by Colonel William T. Craighill. His team, along with succeeding teams, surveyed six routes plus the existing canal. They included the Choptank River in the south, the Wye River, two different routes using the Chester River, the Sassafras and the so-called Back Creek route, which essentially followed the current canal. Craighill would be involved in numerous surveys over the next twenty years and consistently recommended the use of the current canal.

Baltimore felt that politics were in play and objected to any discussion of the existing canal. It held on to the belief that shippers would bypass Baltimore rather than traverse a northern route such as the C&D. President Cleveland established the Casey Commission in 1894 to examine the available surveys to determine the best route for a ship canal. The commission looked closely at Craighill's surveys that had been completed between 1879 and 1893. It had positive testimony from the Ericsson Line, and it received a report from the president of the Columbian Iron Works

and Dry Docks Company of Baltimore, William T. Malster. Going against the popular choices in his hometown, Malster outlined seven specific advantages of using the northern route: it was located just south of a straight line between Philadelphia and Baltimore; it was the most direct connection between Baltimore and more northern ports; it would offer the shortest passage; it would be the fastest passage even given reduced speeds; the engineering problems with the current canal were known; it was the best protected in times of war; and ice would not be a problem. This last was not completely true, but the letter was effective in convincing the Casey Commission. It reported to Congress on "all grounds that the most feasible route" was the Back Creek one, essentially the current canal.

Baltimore interests renewed their objections, producing enough differences of opinion that a subcommittee of Congress recommended the appointment of yet another commission in 1901. The resolution failed to pass for several years until a meeting, the Ship Canal Convention, was held by a variety of canal supporters in Wilmington in early 1904. The dinner brought together a distinguished group of experts to make a series of speeches in support of a ship level canal and to pressure Congress into further action. The approach worked. Congress passed a bill to have the president appoint the three-man commission. Roosevelt responded with the Agnus Committee in 1906 to study the viability of both a thirty-foot and thirty-five-foot canal owned and operated by the federal government.

Public hearings were held, and the canal company supplied all of its financial records to the Agnus Commission but refused to set a potential sales price, simply stating that it believed that the value of the canal property was slightly more than $4 million, which combined the cost of the original construction, maintenance improvements and profit and losses. It claimed that its stock was valued at $1.9 million, an inflated number, and that its bonds were worth $2.6 million, an accurate figure. The commission arrived separately at a figure of $2.5 million since it deemed the stock to be worthless.

The Agnus Commission estimated the costs of converting the C&D at $20,761,000 for a thirty-five-foot channel and $17,300,000 for a thirty-foot canal. The Sassafras route, the only other logical route in its mind, was priced at $21,000,000 and $18,000,000, respectively. They recommended the existing route for a number of reasons, including the fact that more bridges would have to be built along the Sassafras River route. They expected shipments through the canal to reach $2,000,000 including two million tons of coal that was currently shipped outside the coastline. The Agnus Commission also noted that the ship canal would be "of great strategic value

as an adjunct to our land and naval forces." The commission submitted its report to the secretary of war in January 1907.

Congress soon introduced a bill to buy the C&D at a price of $2.5 million, a figure that upset the canal company's directors. The company responded by outlining to Congress the canal's value and advantages to the United States and reviewing the company's history since 1829. The company concluded that the C&D was even more valuable now since its business, if not revenue, was steadily increasing. It again made the claim that the property's value was $4 million. The company's protests were heard in Washington, D.C. Congress did not approve the bill of purchase that year, 1907, nor at the next attempt in 1909.

The piecemeal inactions by Congress fired up the private Atlantic Deeper Waterways Association to become the chief advocate of the Chesapeake & Delaware, believing that it would be a key component in an inland waterway that would run from Maine to Key West, now known as the Atlantic Intracoastal Waterway. The association's longtime president, J. Hampton Moore, was a Congressman from Pennsylvania for fourteen years and a two-time mayor of Philadelphia. He was also an effective public speaker, an adept organizer and a creative promoter. He had delegates from Philadelphia transported through the canal to the association's 1908 convention, held in Baltimore. He received support, and occasional attendance at association meetings, from two presidents, Roosevelt and Taft. President Taft was a speaker at the 1909 annual convention and pledged his support for the construction of an inland waterway, stating that the C&D, because of its central location, was a key part of the greater vision of a two-thousand-mile connected waterway along the East Coast.

The canal continued to struggle financially during the endless debates. The average annual maintenance costs had increased between 1906 and 1917 by a staggering 56 percent and were more than the company could afford. It was failing to pay the interest on the debt. The company's attorney, Charles Biddle, explained to the loan holders that there were only two options available. One was foreclosure, and the other was to grant a further extension. He claimed that extension was the only proper course for the bondholders to follow. The canal continued to advertise that vessels with ten-foot drafts could transit safely, but by the time of World War I, the waterway had silted in enough that boats with nine-foot drafts were having problems. Tonnage, which had increased for a few years, began to decline. The canal could not accommodate the newer, 2,500-ton barges. The canal's largest customer, the Ericsson Line, was paying rates less than the costs, although

the Ericsson Line was receiving increased competition from the Southern Transportation Company. Even World War I could not reverse the trend. The pressures on the canal company were growing.

Efforts continued in Congress, but bills calling for the canal's purchase failed because of negative votes from representatives from the West and Midwest. The Atlantic Deeper Waterways Association was encouraged by another study conducted by the Army Corps of Engineers in 1912. Its report, submitted to Congress, recommended that the canal be purchased for $2,514,000 and estimated the cost of converting it into a ship's canal with twenty-five-foot depths at $9.9 million. It also recommended that $3 million be made available as soon as possible to begin work on dredging the canal to keep the mean water depth at twelve feet. It also recommended that the east end of the canal be moved two miles south of Delaware City to Reedy Point, allowing better deep-water access. The section of the existing canal that ran through Delaware City would be retained for small vessels. It estimated that shipping costs would be reduced by over $1 million, even if there was no increase in tonnage. Congress once again failed to act, and the 1912 and 1913 versions of the Rivers and Harbors Act contained no provisions to purchase the C&D.

One factor that perhaps was delaying the government purchase of the canal was the fact that the government was suing the canal company. It claimed that its share of the 1873, 1875 and 1876 stock dividends had not been paid. The $51,000 error had been discovered during a 1900 audit, but the suit was not filed until 1912. The initial case was heard in 1913, and the company lost. It appealed and the case was reheard in 1914. The company admitted owing the government the money but stated that no proof had been offered that the dividends had not been paid. A jury hearing the retrial returned a guilty verdict and directed the company to pay the government dividends plus interest for a total of just over $60,000.

The case was again appealed and then went to trial for the third time in 1916. The legal team for the government took more care in developing its legal arguments and had clear records that showed that no money had been paid. It also had a deposition from the former secretary-treasurer, J.A.L. Wilson, who had served five years in jail for embezzlement. He admitted that he and others had stolen the money intended to pay the government's dividend. The award this time was $63,000, and it went back to the U.S. Court of Appeals, which upheld the lower court's verdict. It stated that it was unfortunate that the money had been stolen

Three engineers at work inside the headquarters building.

but that the company owed the government the dividends. It pointed out that no reversible errors had taken place at the trial.

The canal company was fortunate that the government was in the process of determining a value for the canal and never asked for the dividend to be paid. Determining the canal's value was not an easy task. One Congressional committee recommended the price be set at $1.3 million. The Committee on Coast and Inland Surveys, under the direction of Delaware senator William Saulsbury, conducted a study and arrived at a figure of $2.25 million. The company still refused to set a price.

Another bill was introduced in Congress in 1917 that called for a $20 million lump sum to go to the Army Corps of Engineers to use on already-approved projects. The bill was defeated primarily through a filibuster led by two senators, one from Ohio and one from Iowa. Senator Saulsbury and the Atlantic Deeper Waterways Association claimed that they based their resistance on out-of-date reports. They introduced a resolution calling for the secretary of war to set a price for the purchase of the canal.

An attempt to include the purchase in the Rivers and Harbors Act of 1917 was made, setting the price at a low $1.3 million. The outbreak of World War I caused a new bill to be introduced that authorized the president to seize the canal for strategic purposes. That effort, along with another one by Senator Saulsbury to have the purchase included in an appropriations bill, failed.

Saulsbury, along with Congressman J. Hampton Moore, then reintroduced the purchase in a new Rivers and Harbors Act. This time,

after a prolonged fight, they succeeded. The government was authorized to set a purchase price and take over the C&D Canal. A final price was arrived at in a 1918 conference between the canal company and government representatives. It was set at $2,514,289.70—the figure arrived at by the Agnus Committee in 1907.

The formal transfer took place on August 13, 1919, and the 116-year existence of a private canal was over. It immediately became a toll-free waterway but, more importantly, was about to go through its largest physical transition.

A NEW CANAL

August 1919 saw three major changes in the Chesapeake and Delaware Canal. The first occurred when, after 116 years of private operation marked by continuous financial and maintenance problems, the U.S. government stepped in with a purchase price of $2.5 million, eliminating the canal company and all of its debts. The stockholders received a zero return on their investment. The Army Corps of Engineer, charged with running the canal in the future, put out a map and folder that described the long history, from the first surveys through the efforts to receive federal aid.

The second major change was that the canal immediately became a free waterway. The years of fighting the railroads and other competitors over tolls came to an abrupt end. Freight and passengers would pass through at no charge. The last full year that tolls were recorded was 1918, and records showed total tonnage at 686,000, down considerably from the previous years, and revenues of $192,000, slightly up from the average of the years 1914 to 1917. It was announced at the last meeting of the canal company's board of directors, held in June 1919, that it would miss its interest payment on its debt by $88,000.

The last major change was that plans were immediately announced for reshaping the C&D into a lock-free, sea level shipping canal. It would initially be expanded to a consistent depth of 12 feet with a 60-foot width at the bottom. There were to be five new highway bridges and one new rail bridge constructed. The major issue was that sixteen million cubic yards of dirt would have to be moved while the canal stayed open. These initial plans included provisions for the canal to be further expanded to depths of 30 to 35 feet and a width of 250 feet.

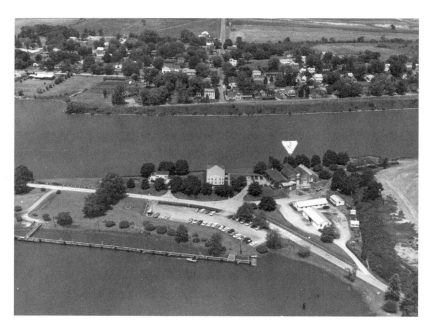

Above: An aerial view of Chesapeake City that shows the white frame headquarters building and, to its right, the old pump house, now home to the museum.

Below: Two barges with cranes are working at enlarging the canal in the 1920s.

The initial appropriation of $3 million was used in 1920 and 1921 to make only the minimum improvements required to maintain the canal. Colonel Earl Brown of the Army Corps of Engineers office in Wilmington was put in charge of the project of reconstructing the entire canal. The initial twelve-foot enlargement was scheduled to be completed in 1926, but work ran into problems from the beginning. The biggest challenge for Brown, the engineers and the contractors would be the same one facing their predecessors in the 1820s: the unstable marshes at the east end and the walls of the deep cut section. These issues were compounded by the fact that the decision had been made to relocate the east entrance of the canal to a spot two miles south of the existing terminus in Delaware City. This was an area called Reedy Point and was almost totally surrounded by low-lying tidal marshes. The chief engineer described the challenges in a 1931 report to the American Society of Civil Engineers as being very similar to those encountered when the Panama Canal was constructed.

The plans called for a dredge to be shipped from New York to Delaware via the sea. It ran into storms and sank, creating a $500,000 loss. Another one was ordered to be delivered in August 1926, but Brown elected to delay removing the locks and opening the sea level waterway until February 1927. The first traffic, restricted to boats drawing less than 9

One of the many contractors used was the Essiling Company from New Jersey. This image shows six of its employees on the job during the 1920 expansion.

Above: The crane with shovel is hard at work in what looks to be the deep cut during the expansion of the 1920s.

Below: The old locks, loaded on a barge for removal. The ship level canal made for both a safer and more commercially viable waterway.

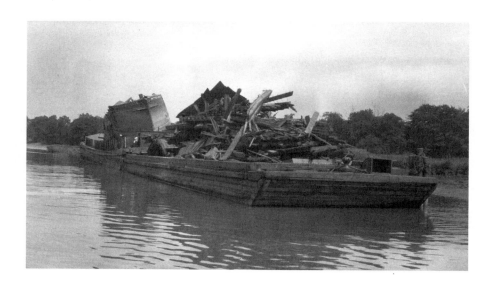

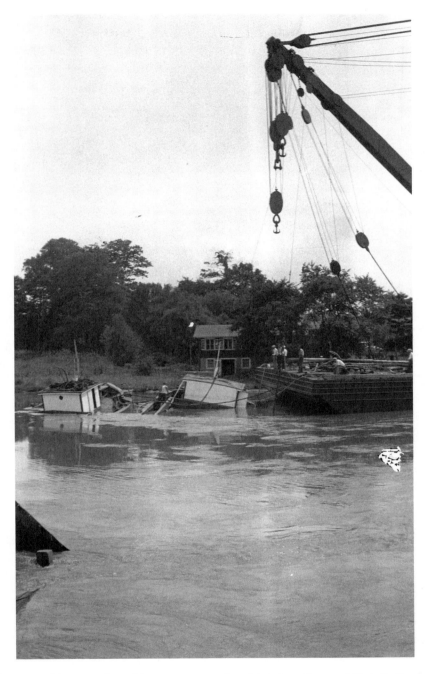

A crane and barge are in position to remove sunken debris from the canal. Periodic floods sank ships that were in the process of transiting the canal. Some floods placed the vessels two hundred yards out of the actual water.

Dynamite was also used to break apart the hard soil on the bottom of the canal. This image shows contractors setting off a blast. The barge with the crane and shovel would then move closer in order to remove the loosened mud.

feet, went through on the first day of the month, but it took almost the rest of February to remove the remaining landslides and locks. Brown still placed restrictions on speeds, the height of the vessel and the number of tows. The new bridges, all of the lift type, were operational and could rise to a height of 175 feet when opened. This was done in anticipation of the further expansion of the canal. The new canal cost $10 million, including the initial $2.5 million for the purchase.

Brown, in his 1931 speech to the Civil Engineers society, also discussed the economics of the new and improved canal, suggesting that shipping savings in 1926 alone amounted to between $600,000 and $700,000. He also said that the canal needed further work for safety reasons. He said, "The detriment [of the current canal] lays not so much in their effect on speed and time of transit, but on the safety to the vessel. If a large and heavily laden vessel grounds and goes athwart the channel, as it may well do under the actions of currents, a fall in tide may break the vessel in two."

The problem is that, because each end originates in a tidal body of water, the canal experiences varied tide times and currents that are slightly out of phase with one another. It can be high tide later at one end than the other. Tides tend to be higher at the western end, though not always, and as a result of the waterway having two separate tides, currents can ebb and flow quite strongly. Brown felt that these tidal differences were "detrimental to navigation."

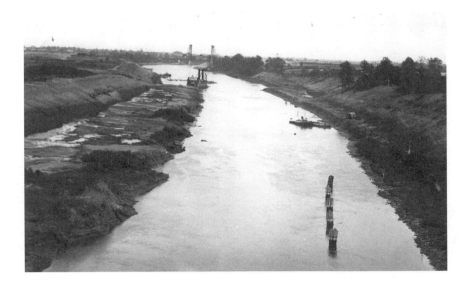

Above: An aerial view of the canal being enlarged. This gives a good idea of how much material had to be removed to expand the waterway. A lift bridge is visible in the distance.

Below: A view of the newly widened C&D Canal. Piers were constructed along the canal that allow people to fish in the waterway, as well as provide emergency docks to tie up to if trouble arises.

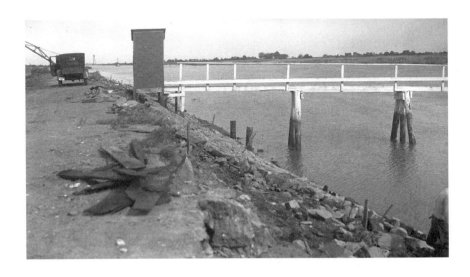

Above: One of the many ceremonies held over the last two hundred years that dedicated a newly revised waterway. This looks to be in the 1950s but may have been later in the 1960s.

Below: The canal in winter with a lift bridge in the lowered position in the background. Ice blocked the use of the canal for many winters, but modern icebreakers, and more moderate weather, allow the canal to be used virtually every day of the year.

A New Canal

Another winter view of the expanded canal showing a barge being moved through the canal by a tug tied to its side.

Brown expanded usage of the canal in May 1927 to include vessels drawing twelve feet, not to exceed sixty-four feet in length, and tows were limited to one barge. Speeds were kept to six miles per hour. The celebration of the new canal was held on a rainy May 14, 1927, and was attended by the Maryland governor, various Congressmen and civic leaders. President Calvin Coolidge pressed a button in Washington, D.C., that marked the official opening. The speeches gave much of the credit to the Atlantic Deeper Waterways Association for its persistence in pursuing the revised canal.

The new canal was a success; 431,000 tons of freight was shipped through the canal in 1920. The first full year of a sea level canal, 1928, saw more than 700,000 tons. That figure grew to 1,000,000 by 1932. Newer and larger ships were making the transit, carrying passengers, various goods and a new, important commodity: oil. Foreign steamers were using the canal with some frequency, as were pleasure boats.

Passage had become so heavy that a rough traffic control system was introduced consisting of a central dispatching office in Chesapeake City and patrol boats stationed at either end of the canal. The bridge tenders were enlisted as traffic control officers. When a ship entered at either end, the patrol boat would use a radio telephone to announce the ship to the other stations. The vessel's progress was reported as it passed each bridge, and the final patrol boat would report that the ship had left the canal. The dispatch office in Chesapeake City kept track of all the transits.

This increase in traffic was also increasing the demand for further expansion. The advertised twelve-foot depth was not always available, and landslides continued to plague the canal. Colonel Brown said that there was no known cure for the banks caving in until some state of equilibrium

was reached. Until then, "navigation will experience the hazard of occasional interruption," according to Ralph Gray's *The National Waterway*.

The House Committee on Rivers and Harbors met in January 1932 and requested that the board of engineers for Rivers and Harbors make a recommendation. Colonel Brown's report suggested a widening of the canal to 250 feet and increasing its depth to 25 feet. This expansion was estimated to cost $9,788,000. His boss in New York made a second recommendation, calling for a cost of only $2,900,000, but the board of engineers approved Brown's plan and actually expanded it to have the final depth be 27 feet. Various other reports justified the economics of Brown's report based on increased shipments from the use of more, and larger, vessels.

Congress appropriated $5 million for the project, which also included a deepening and widening of the channel in the Chesapeake Bay from the Elk River to Poole's Island in 1935. The new canal would become the even newer, and better, canal.

THE WEST END OF THE CANAL

The earliest people to populate the Delmarva Peninsula walked the route along which the C&D was eventually constructed. It was the shortest point between the marshy coastline of the Delaware River in the east and what later became known as Back Creek in the west. That connected with the larger Elk River, which emptied into the Chesapeake Bay a few miles farther south. The nomadic Native American tribes had easy access, both on land and water, to both hunting grounds and fertile land for growing corn and other crops.

The advantages of this short, fourteen-mile neck were not lost on the first European settlers. Almost as soon as they reached the upper Chesapeake, a small village of two to three houses appeared at the upper end of Back Creek. It was located on the land held by Augustine Herman. He called his twenty-thousand-acre farm Bohemia Manor, and the small group of houses on Back Creek became known as Bohemia Village.

Augustine Herman was one of the first to propose a cross-Delmarva canal, but it took several more decades before his vision became a reality. After several abortive starts, the Chesapeake and Delaware Canal was completed in the 1820s. Bohemia Village began to prosper because of its location at the west end of the canal. It was a natural location for the workers, who were constructing the canal to thrive. A tavern, a small hotel, a sawmill, a tannery and a small wharf were built. Several more houses appeared. The population was growing. The locks, constructed at the head of Back Creek, meant that traffic transiting the canal had to stop in the village, fueling more economic growth.

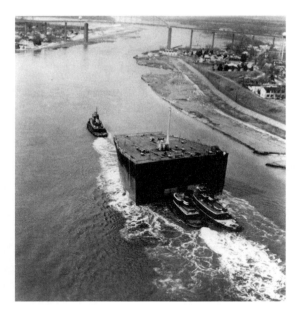

The front section of the tanker SS *Manhattan*—built for the Humble Oil Company, now known as ExxonMobil—is being moved in June 1969 by the three tugs. This 115,000-ton section was built in a shipyard in Philadelphia and is headed to Newport News, where it would be joined to the other section that had been built in Mobile, Alabama. The tow is nearing the Route 213 Bridge in Chesapeake City. *Courtesy of the Cecil County Historical Society.*

John Randel, later to become famous for his involvement in a lawsuit that crippled the canal company, purchased the village believing that it was destined to become a major city, but financial pressures brought on by his passion for filing lawsuits forced him to sell the property in 1829, the year the new canal commenced operations. The town changed its name to Chesapeake City in honor of the new waterway. The community was split, with half on the north side of the canal and the remainder on the south shore. The two sections were connected by two bridges. Children went to school in the south, and many people crossed each Sunday morning for church. Bethel, an even smaller village located east of Chesapeake City, also had a bridge, and people freely crossed between the two shores depending on the task at hand.

The village continued to grow with the popularity of the canal. A post office was added in 1839, a sure sign that a town was thriving. Lumber, shipped up and down the canal, became a major commodity for the community. Trade in the product reached such a large volume that the State of Maryland appointed a resident lumber inspector. The population reached four hundred in 1850 and became an incorporated town.

Traffic through the canal grew, increasing the size of Chesapeake City, with the population peaking in 1876 at 1,400 people. Most people worked for the canal or for companies that used the canal. The Southern Transportation Company established its shops and docks on the south shore. It built, owned

and operated dozens of barges and tugs. It was second only to Ericsson in size, and the townspeople worked as carpenters, maintenance men or on the boats themselves as captains and crew members.

Ice was also a big commodity. The canal pond at the upper end of Back Creek, behind the steam pumping station, now commonly referred to as the engineering basin, was a natural place to cut ice during the winter months. Icehouses sprung up along both shorelines. The fresh-cut ice would be covered in sawdust and stored until it was needed in the warm summer months.

Chesapeake City began to suffer growth problems toward the end of the nineteenth century. The movement to build a new sea level ship canal reached its zenith, and five of the six proposed possible routes bypassed Chesapeake City. The canal, and the canal towns, went into a twenty-year holding pattern. Chesapeake City was saved from certain death when the federal government purchased the canal in 1919 and immediately began widening the existing canal. Chesapeake City lost the locks, which meant that people did not naturally stop, but the Army Corps of Engineers charged with maintaining the revised canal chose the town as the location for its main office. The Ericsson Line continued to visit Chesapeake City until the 1940s.

The town had to be moved back on both sides to accommodate the new, wider canal. On the north shore stood the wharf and store of the Schaffer family. Schaffer's Canal House was a one-hundred-year fixture along the canal, first supplying Southern Transportation Company and the Deibert Shipyard with material to build barges and tugs. Later, after moving farther back on the north shore each time the canal was expanded, it began supplying pleasure boats. The store sold food, fresh meat, bread and candy, as well as soft and hard drinks. It was advertised as the complete ship's chandler. Boats would anchor in the engineering basin and row across in dinghies to shop. As one yachtsman said, "Everything from needles to anchors."

Schaffer's also supplied the boats used by the pilots guiding ships through the canal. Chesapeake City is where a pilot transiting the canal from east to west must leave his vessel and be replaced with a Chesapeake Bay pilot. The pilots stayed at lodging supplied by Schaffer's. Their boats would take the new pilot out alongside the still moving freighter. The oncoming pilot would climb a rope ladder to the deck and the outgoing pilot would climb down and be returned to the north shore. The store eventually became a well-known restaurant and small guesthouse. Families would plan their Sundays around eating a meal at the Canal House. The Schaffer family eventually sold the operation. The new owner ran it for several years but

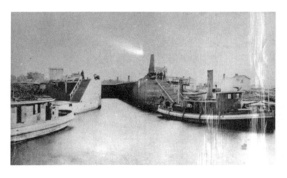

The pilot vessels wait at Schaffer's Canal House. Schaffer's ran a chandlery, a marine store, a restaurant and guesthouse, as well as supplied the housing and transportation for the pilots needed to move vessels safely through the canal.

eventually had to close. It remains shuttered, though signs as you enter town announce that there are plans to reopen. Tugs still use the wharf.

The largest controversy to hit the community was in 1966 when it was announced that the Ohio-based rubber and tire company B.F. Goodrich was interested in building a chemical plant on a one-thousand-acre parcel of land that ran on the north side of the canal from Route 213 to the Delaware line. The zoning on fifteen properties had to be changed to heavy industry in order for the owners to sell their land to Goodrich. The Army Corps of Engineers also noted that Goodrich had applied for a lease to build a dock for large ships on government-owned land along the canal.

Lines were immediately drawn among the local residents. One side pointed out that the plant would create a number of new jobs in an area desperate for employment. The other side was concerned that the rezoning would open a floodgate of new requests, and soon the entire area would be one large petrochemical plant. The Army Corps of Engineers took the proposal under study, while the Cecil County Commissioners tabled the zoning requests until the planning commission presented its final report. A public meeting was scheduled for February 9, 1967.

The meeting was held at Bohemia Manor High School and was the largest gathering ever held in the county. Both sides presented their points, with arguments rising at every turn. The final speech closing the meeting was finally presented after midnight. A month later, the Army Corps of Engineers announced that Goodrich had withdrawn its application due a pending lawsuit that had been filed by Cecil County landowners to block the zoning changes and that the company, while secure in believing that it would win, could not afford a two- or three-year wait to build the plant. The controversy over the possible construction of the plant continued after Goodrich left. It was later found that the plant would have used more than 2.5 million gallons of groundwater per day on a site not known for

The West End of the Canal

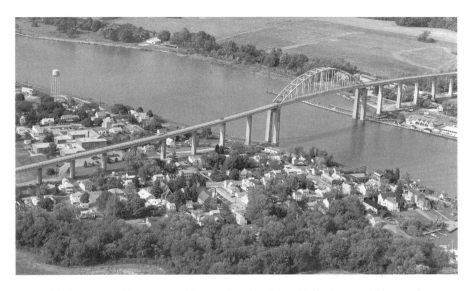

An aerial view, primarily of south Chesapeake City, although the Route 213 Bridge is shown along with the buildings and wharfs at Schaffer's Canal House.

an abundance of water, confirming the pollution concerns discussed at the public meeting. There has been little to no effort since the mid-'60s to industrialize the land along the canal.

Time and events such as the Great Depression had a negative impact on the community. By 1960, despite a new highway bridge built and maintained by the Army Corps of Engineers, the town was dying. Community leaders saw the population drop to its lowest level in a hundred years. Plans were put into place to revitalize Chesapeake City. The old nineteenth-century buildings were converted into stores and new restaurants. The Army Corps of Engineers opened a museum next to its headquarters. New businesses came to town, and by the beginning of the twenty-first century, Chesapeake City, now with a population of 787, had recaptured some of its early glory as a destination for tourists and shoppers.

THE EAST END OF THE CANAL

The west end of the C&D Canal was chosen early in the initial surveys of possible routes across the Delmarva Peninsula; the eastern end was a subject of much speculation. Christiana Bridge was the favorite terminus until actual construction began. It was decided that the canal should exit into the Delaware River at a point where a small community, Newbold's Landing, had been established. The reason the canal was located at this spot was not because of the town but rather the fact that Fort Delaware had been built on an island directly off the mainland and would serve as security for the new waterway.

The two Newbold brothers from New Jersey had two thousand acres conveyed to them in 1801. They laid out the town in 1826 in anticipation of the soon-to-be-opened canal, which would turn the small village into a major shipping port that would rival Philadelphia. They immediately gained credibility when a post office was established that same year, but financial burdens forced them to sell the community in 1828. It was renamed Delaware City.

The canal initially proved to be an economic benefit. The town became a major shipper of peaches, lumber and fish caught in the Delaware River. Other small industries were established in town, including a blacksmith, a carriage shop, a sheet metal factory and a mincemeat factory. The Central Hotel, also known as the Sterling Hotel, opened at the corner of Clinton and Canal Streets to accommodate the passengers who boarded the Ericsson Line's steamboats at the Delaware City locks.

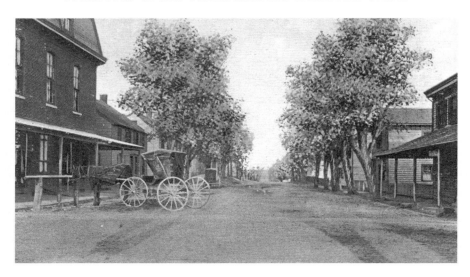

The main street of St. Georges, Delaware.

There is no doubt that the community benefited from the establishment of Fort Delaware on Pea Patch Island and later Fort DuPont on the mainland at the edge of town. The planned military presence helped ensure that the new C&D Canal would run near, or through, Delaware City. Pea Patch Island, named because a boat carrying peas hit a shoal and foundered at the site, had been surveyed as a possible defensive position as early as 1794 when Lafayette, the French army officer who served as George Washington's right-hand man during the Revolutionary War, was sent on a mission to find suitable locations to defend Philadelphia from invasion. He recommended what nautical charts referred to as Pip Ash Island. No action was taken, but the outbreak of the War of 1812 emphasized the fact that Philadelphia was still defenseless.

The federal government tried to buy Pea Patch Island for $30,000 from Dr. Henry Gale of New Jersey, who claimed that the land belonged to him. He turned the offer down, and the Delaware legislature seized the property and ceded the island to the federal government in 1813 for defense purposes. The ongoing war delayed construction, and the first timbers were not set until 1818. Work proceeded slowly since all of the material had to be shipped by boat. The fort, named Delaware, was opened in 1826 under the command of Major Samuel Babcock, but fire destroyed the wood structure in 1831. The new commander, Major Richard Delafield, took a $10,000 appropriation to tear down the remains of the structure and begin work on a sturdy replacement, but there was an almost immediate delay. Dr. Gale had

A view of Delaware City taken prior to World War II.

filed a lawsuit stating that he still owned the island. His death did nothing to stop the claim. John Humphrey picked up the cause, saying that he was the rightful heir. The claim was not resolved until 1848.

Major Delafield had designed what was to be the largest fort in the country. Congress authorized the plans, and the new structure was started in 1849 but immediately ran into trouble. The yellow pine logs being set as footings sank deep into the muddy land of the island. Construction costs hit $1 million, and work was halted until Congress could approve the new funding asked for by Secretary of War Jefferson Davis. Congress authorized $750,000 in 1856, and the fort was completed in 1859. The brick and mortar structure, which still stands today, cost $2 million and was built in a pentagon shape with two sides facing the water. Gun embrasures lined the walls. These were filled with twenty thirty-two-pound cannons and twenty howitzers.

The fort's mission changed at the outbreak of the Civil War. Space was needed to house Confederate prisoners of war. A group of 258 Virginians captured in the Battle of Kernstown in April 1862 were soon joined by more men from other battles. Wooden barracks were built to house 2,000 prisoners. The battle at Gettysburg expanded the number to more than 12,000 men in 1863. Conditions were poor. Food was scarce, water was rare and scurvy and smallpox epidemics decimated the population. More than 2,500 men died on the island during the course of the war. Legends persist to this day that the site is haunted by the ghosts of Confederate prisoners. The fort has been featured in episodes of the Syfy TV network's *Ghost Hunters* and the British

show on paranormal activity *Most Haunted*. At the end of the war, 7,000 men were released, and the wooden barracks were torn down.

Fort Delaware was declared obsolete in 1869. The federal government used the fort for several more years but turned it over to the State of Delaware in 1947. A state park and memorial was established, and the fort was restored to pre–Civil War conditions. Today, thousands of visitors take a ferry out to the island during the summer, and there is even an "Escape from Fort Delaware" triathlon in which the contestants follow the route used by the fifty-two prisoners who escaped the island during the Civil War.

Military planners in the nineteenth century believed that Philadelphia and Washington, D.C., still needed to be protected. Fort DuPont, named for Rear Admiral Samuel DuPont, was one of several forts that formed the Fort Circle of Parks. First constructed along the western shoreline of the Delaware River just outside Delaware City as a series of earthen dikes, the layout was expanded at the end of the Civil War. Fears of invasion subsided, and by 1870 only a token force was left in place. The War Department updated the plans for the fort as the country neared the Spanish-American War, but the fort was again downsized after that conflict ended. World War I revitalized the fort for a short period of time, but by 1920 the Civil War–era cannons and ammunition were sold as scrap. The site became a prisoner of war camp for German and Italian soldiers captured in the fighting in Northern Africa, but Fort DuPont was abandoned again at the end of the war until it was returned to the State of Delaware in 1948. A park was established there and is open to the public.

The presence of Fort Delaware, and later Fort DuPont, helped Delaware City when the first canal route was surveyed, but the marshy soil at the east end was a constant maintenance headache. When the federal government purchased the canal in 1919, plans were immediately drawn up that moved the outlet of the canal several miles south of Delaware City to the deeper waters of Reedy Point. The new, wider and deeper canal allowed better access to the waterway. The old canals and locks were left in place, but the town had been effectively bypassed.

Many of the town's people believed that if their channel could be built the same size as the main branch of the canal, the town would once again see freight and passenger services. The town petitioned the Army Corps of Engineers in 1931 to widen what was now called the branch canal to ninety feet and to deepen to a depth of twelve feet. They wanted the locks removed to allow free passage along the old route. This would restore the town's glory. The Army Corps of Engineers noted the cost, estimated at $343,000, to be prohibitive and recommended the branch be reconstructed to eight feet of

depth and fifty feet wide at a cost of $67,000. This would allow pleasure craft access to the community.

The Army Corps of Engineers included the cost of the small expansion in the 1935 widening of the main canal, but Delaware City would never see the return of more prosperous days. The community never threatened Philadelphia as a center of trade and today exists primarily as a tourist stop for those visiting Fort DuPont and Fort Delaware.

BRIDGES

One issue that the Chesapeake and Delaware Canal has had to deal with from the beginning was the need for people and transportation to get across the canal. The number and types of bridges has changed over the years, but traditionally there have been six road bridges and one railroad bridge. In 2010, there are five major highway bridges and one railroad bridge in operation. There is the Maryland Route 213 Bridge at Chesapeake City. Farther east is the Summit Bridge for Delaware Route 896. A mile or so east is the Norfolk-Southern rail bridge, which is the lift type. The original St. Georges Bridge handles traffic for Delaware Route 13. That highway was bypassed by an extension of Delaware Route 1, which allowed travelers a modern, four-lane, limited access road around Wilmington and Dover. That bridge, just east of the original St. Georges Bridge, was completed in 1996 and is universally known as the Chesapeake and Delaware Bridge, although the official name is the Senator William V. Roth Jr. Bridge. The bridge farthest east is the Route 9, Reedy Point Bridge, which spans the main canal. A small bridge still crosses the old branch of the canal at the west end of Delaware City.

The first bridges were completed as soon as the original canal was finished. In Chesapeake City, the Long Bridge crossed Back Creek and was designed as a horizontal swing bridge. A wheel was turned and the bridge opened. The canal itself was crossed with the High Bridge. It was an A-frame construction. A cable lifted the bridge and swung it to the north side to allow traffic to pass. These bridges were held in service until the locks

The United States Army Corps of Engineers supplied their civilian Bridge Tenders with uniforms during the early years of government operation of the Chesapeake and Delaware Canal. Mr. Edgar Price Rhoades, also known as "Friday", was the operator of the old Chesapeake City Lift Bridge prior to his death in 1942. This photograph dates back to 1937.

were removed in the 1919 canal expansion and replaced by a lift-type bridge, for which the road deck was actually cranked up to a clearance height of 140 feet. That proved to be unsatisfactory since the bridge was hit several times. In 1942, the tanker *Franz Klasen* was being assisted through the canal by three tugs when it crashed into the south tower of the lift bridge, bringing down the entire span. Ferries, first the thirty-five-car *Victory* and later the larger *Gotham*, were pressed into service. These were the only connections between north and south Chesapeake City until the modern highway bridge was completed in 1949. That same bridge, owned and operated by the Army Corps of Engineers, is still used for Route 213.

They are no longer needed, but for years each bridge had a tender. They were at first employees of the private canal company and later were members of the Army Corps of Engineers. Their responsibilities included moving the pivot bridges (or later the lift bridges) and traffic control. Several bridge tenders were killed when ships hit the bridges.

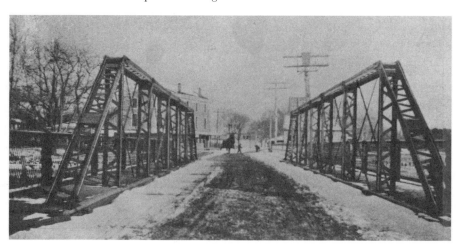

The Long Bridge, one of two original bridges, in Chesapeake City.

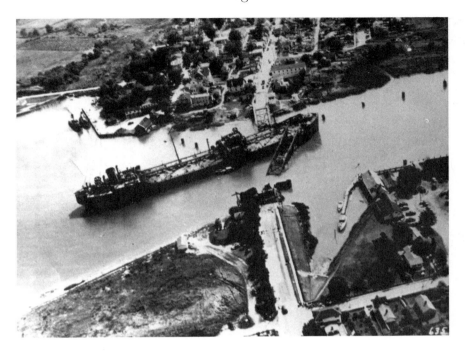

The lift bridge in Chesapeake City is hit by the *Franz Klasen* on July 28, 1942. The collision brought down the entire span isolating north and south Chesapeake City from each other. Ferries were pressed into service until the current highway bridge opened in September 1949. *Courtesy of the Cecil County Historical Society.*

The town of Bethel was located a few miles east of Chesapeake City, and for years the two sides of the town, north and south, were joined by an A-frame bridge. That structure stayed in service until the canal was widened in the 1920s. The decision was made to not replace the bridge, effectively reducing Bethel to a ghost town. The historic church that had served the community for decades closed and was torn down in 1965 during another expansion of the canal. All that remains today is a cemetery and a few houses.

The Summit Bridge, often called the Buck Bridge by locals, began life as a high-span covered bridge at 327 feet. Five more configurations followed as highway traffic increased and the size of the canal grew. The original was replaced by a Howe Truss iron bridge in 1868, which pivoted on its own center point to allow canal traffic through. The third Buck Bridge was constructed to provide more clearance but used the same piers as the previous model. That was again replaced in 1927 by a lift-type bridge and,

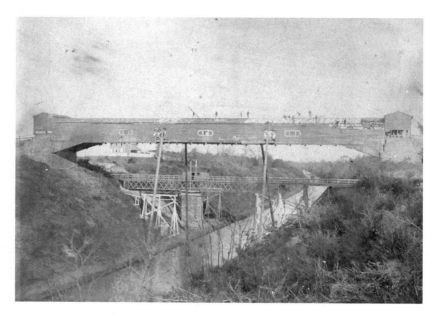

Above: The covered Summit Bridge being disassembled about 1880. *Courtesy of the Cecil County Historical Society.*

Below: This version of the Summit Bridge replaced the previous covered bridge.

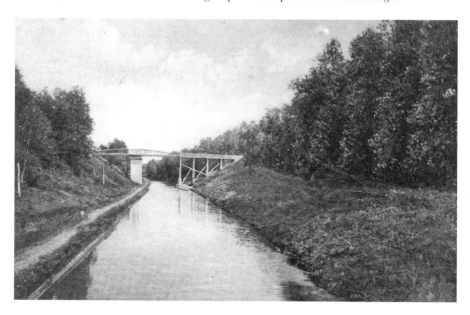

finally, by the modern highway bridge completed in 1963. Its four lanes carry traffic on Route 896.

The railroad bridge, now used by Norfolk-Southern, was first built for the Delaware Railroad Company in 1831. The original was the site of a major railroad disaster in 1862 when a train left New Castle with twenty-five laborers in the middle of an ice storm. The plan was for the train to move south and pick up a load of wood. As it neared the canal, the brakeman looked ahead to make sure the drawbridge was closed. Visibility was low. He realized too late that the bridge was raised for canal traffic. He hit the brakes, but the train skidded on the icy rails, plunging the engine into the canal and wrecking the cars behind. There are two theories as to why the accident happened. The first is that the engineer, Josiah Anderson, must have lost sight of where he was in the ice storm. He was killed along with the fireman and seven others. The other theory, one claimed by the brakeman, was that the lights indicating the bridge's operation position were not working. The original bridge was replaced by a lift bridge during the 1920s. The current lift bridge was completed in 1966. It raises high enough to allow even the largest ship to pass underneath. It is normally in the raised position to allow free ship travel. A train engineer must notify the Army Corps of Engineers thirty minutes before any crossing so the bridge can be lowered.

The bridge at St. Georges also started as an A-frame. It was located at the west end of the St. Georges locks. This was replaced first by a lift bridge in

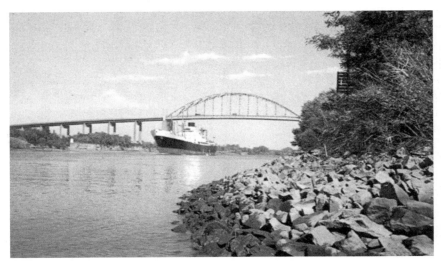

The modern Summit Highway Bridge that carries traffic on Delaware Route 896. The shoreline is covered in large stone riprap, which is one way that the Army Corps of Engineers prevents erosion.

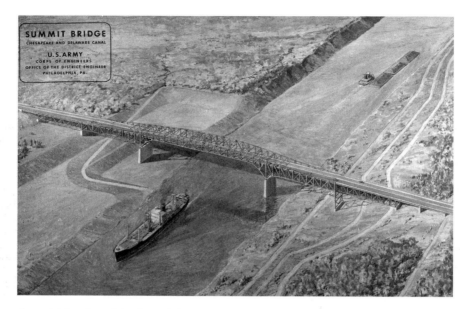

An aerial drawing of the Summit Bridge, which also shows the maintenance roads along both sides of the canal. There is a movement to improve these gravel roads to allow for more recreational hiking, biking and horseback riding. *Courtesy of the Cecil County Historical Society.*

1929, which was destroyed by a ship, the SS *Waukegan*, in 1939, killing the bridge tender, William Oakes. A high-span highway bridge was finished in 1941. It carries traffic on Delaware Route 13 and was closed for several years after the new Delaware Route 1 Bridge was opened. The locals protested, and after a few years, the St. Georges Bridge was reopened to allow residents to cross the canal more easily.

The Senator William V. Roth Jr. Bridge previously discussed was built to handle the traffic from the expanded Delaware Turnpike, known as Route 1. The bridge, a rare cable-stayed bridge, was modeled on the famed Sunshine Bridge that crosses Tampa Bay in Florida. The bridge is six lanes wide, and the upward grade is only 3 percent. There are no center piers, greatly reducing the chance of a ship collision. The bridge was built using precast segments molded in Baltimore and shipped up the Chesapeake Bay and through the canal.

The original Delaware City bridge was constructed at Fifth Street as an A-frame. This was replaced several times until the canal location was moved to Reedy Point in the 1920s. That bridge was first built as a lift bridge and was replaced by the high-speed Highway Bridge in 1960. There is still a small bridge that crosses the branch canal closer to Delaware City. It is a nondescript street bridge common to any small water crossing.

Bridges

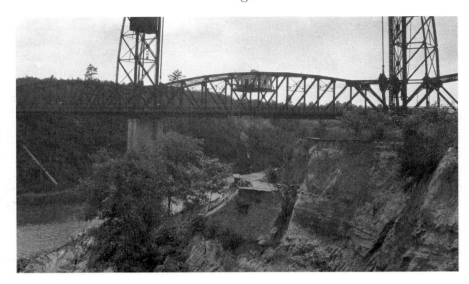

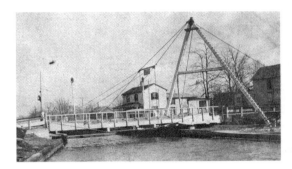

Above: The railroad lift bridge crossing the deep cut. This image shows how unstable the soil could be, particularly after a hard rain.

Left: The first A-frame bridge in St. Georges, Delaware, taken about 1900.

Below: Another view of the same A-frame bridge in Delaware City.

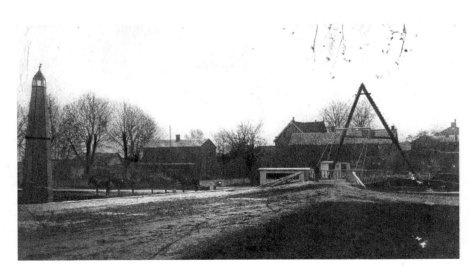

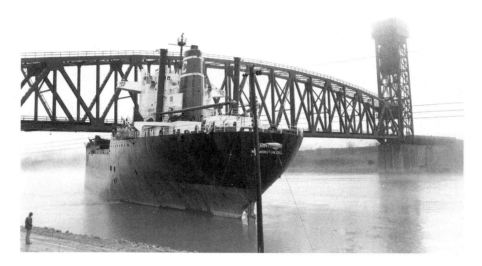

Above: A good view of how low the lift bridges were. This ship could not pass through the canal unless the bridges were raised.

Below: One of the lift bridges in operation. They have all been replaced, except for the one used by the railroad.

Bridges

These six bridges are under the control of the Army Corps of Engineers, and although maintenance is constant, it has been many years since any of the spans has been hit by a passing vessel. It's unlikely, despite occasional public requests, that any further bridges will be built. Traffic is always relatively light, except when repairs are being conducted or summer travelers are heading to the beaches of southern Delaware. The bridges are often overlooked, but they are an important part of the history of the C&D Canal.

ANOTHER WAR

A little-known fact about World War II is how close German U-boats operated to the Atlantic shoreline of the U.S. mainland. They sank 127 cargo vessels off the coast of Delaware and New Jersey between December 1941 and April 1942. The reason that they were not more successful was the presence of the inland waterways that stretched from Maine to Florida and provided cargo ships with a reasonable amount of security. The Chesapeake and Delaware Canal, which was widened and deepened just months before the outbreak of the war, was a key element in this secure route. More than 10,827,000 tons of freight passed through the waterway in 1942 alone.

It had been obvious to all those involved with the C&D Canal that the initial 1920s Army Corps of Engineers project to increase the canal's size was just the first step in a more extensive renovation. There were costly delays as more ships used the canal. The frequency of accidents was increasing. The House Committee on Rivers and Harbors ordered a study be conducted by the board of engineers in 1932 to determine if further construction was needed to "protect and facilitate commerce." The district engineer in Wilmington recommended that the canal be modified to carry 25 feet of depth its full length, with a width at the bottom of 250 feet. The project's cost was estimated at slightly less than $10 million. Another study suggested increasing the depth to 27 feet. The studies all concluded that a larger canal would allow oceangoing vessels access to the waterway, creating sufficient savings in time and costs to justify the expenditure required for construction. It was also recommended that the

shipping canal that runs from the Elk River southward be improved to a width of 400 feet with 45 feet of depth. The entire project would cost $12.5 million, with annual maintenance costs estimated at $200,000.

Another study conducted by the Baltimore Association of Commerce found that 1,035 out of 1,079 ships that visited the Port of Baltimore in 1933 would have used a canal with twenty-five feet of depth, saving hundreds of thousands of dollars in shipping costs. The canal project was listed as "shovel ready," and Congress acted on the reports in 1935, allocating $5 million under Emergency Relief Appropriation; 90 percent of the workers were to come from the relief roles.

Work began immediately. Thirty-five million cubic yards of material had to be removed. The project plans called for both dry excavation and dredging. Two of the bridges had to be altered again to accommodate the new width and prevent dangerous currents. The hardest part, as always, was the deep cut where the soil was still unstable. This time, scientists working at three labs experimented with methods of bank stabilization. The final recommendation was a flatter slope and a much-improved drainage system. Work was completed on the revised canal just weeks before the outbreak of World War II.

The traffic in the canal jumped significantly due to both the war and the timeliness of the reconstruction. Nine thousand vessels transited the canal in 1935. That figure jumped 57 percent over the next five years to more than fourteen thousand in 1940. Freight tonnage more than tripled in the same period. The main goods being shipped in the early years of the war were petroleum, fertilizer, coal, chemicals, lumber, iron and steel. As the war progressed, finished goods such as vehicles, tanks, engine parts, food, uniforms and men passed through the canal, safe from the German submarines that were sticking their noses into Delaware Bay. More than one hundred dry-cargo barges were converted to tankers. They, along with five hundred new tankers, hauled fuel needed for the war effort.

Shipping was interrupted for two weeks during the critical year of 1942. The tanker *Franz Klasen* hit the south tower of the Chesapeake City Bridge, bringing down the entire structure and blocking the canal. The accident was blamed on an inexperienced pilot (those with more experience were in the service overseas). John Schaffer watched the event from his store on the north shore. That section collapsed straight down. If it had fallen forward, it would have crushed the wharf and store. The bridge was abandoned and rebuilt as a highway span after the war ended. The canal carried 10,827,162 tons of freight in 1942, despite the fact that the canal was

closed to navigation during a critical time in the summer when shipping was heaviest.

Eight bridge accidents, along with more than two hundred other incidents of collisions and groundings, occurred during the war years. This concern, combined with the increased traffic of even larger ships, led the Army Corps of Engineers to recommend that the canal be further expanded. The district engineer, Major General S.D. Sturgis, produced a report for the secretary of war that noted that the high number of accidents was due to the difficulty in navigating a 27- by 250-foot channel. He reported that bridge clearances were too low, the water was too shallow, there were still sharp bends and the larger ships could not safely pass because of the canal's narrow width.

It was not until 1954 that the report, initiated in 1939, was finally delivered to Congress. It acted almost immediately, partly in response to the worst accident ever to happen on the C&D Canal.

A NEW PHASE

L ate in the evening of May 15, 1952, the tanker *F.L. Hayes* entered the
C&D Canal at Reedy Point. It was loaded with 640,000 gallons of high-
octane gasoline. It made its way through the darkened canal. A 438-foot
freighter, the *Barbara Lykes*, entered the canal heading east later that same
evening. It was traveling from Baltimore to New York and was one of several
vessels making the same trip. The slightly smaller *Angelina* was close behind.
They were with the easterly tide, while the 240-foot *F.L. Hayes* was fighting
the current. The weather was clear and calm.

The *Barbara Lykes* passed the Summit Bridge about midnight. The lookouts
noticed another vessel showing lights that would indicate it was under the
railroad lift bridge headed toward them. That was the *F.L. Hayes*, which had
pulled close to the north bank of the canal. Its captain said that his vessel
was aground as he waited for the larger vessel moving east to pass. The
navigation lights changed as the two ships approached a sharp bend that was
still part of the canal. Eyewitness accounts vary, but the official U.S. Coast
Guard inquiry noted that the *Lykes* moved near the north bank, with its stern
sticking out into the canal. The *Lykes* rudder responded but too late to avoid
hitting the *F.L. Hayes* along its port (left) side.

Richard K. Smith, a crewman on the *Lykes*, said that the *F.L. Hayes* passed
the railroad bridge on a collision course for the larger freighter. Smith
reported that his captain and pilot swung the ship almost into the bank to
avoid hitting the tanker, but as the *F.L. Hayes* veered away it hit the port side
of the *Lykes* and scraped along the side until it passed behind the freighter.

There is no dispute as to what happened next. The *F.L. Hayes* exploded. The following *Angelina* had to pass through the showers of flaming gas that were flowing off the tanker and covering the water's surface. Only the vessels' captains' quick orders to proceed full speed ahead to get through the walls of flame saved the ship. Several of its crew members were burned fighting the subsequent fires.

The *Lykes* suffered no damage, proceeded to the east end of the canal and dropped its anchor to wait for the Coast Guard to arrive to investigate. The *F.L. Hayes* had four crew members killed by the blast. It floated in the middle of the canal, blocking all further traffic, until the currents pushed it aground on the south bank a half-mile east of the Pennsylvania railroad bridge it had just cleared. It sank there while the fires burned another three weeks.

The canal was immediately closed to all but the smallest craft. There were several aborted attempts to raise the *F.L. Hayes* after the fires had been extinguished. Baltimore shippers complained that they were losing millions of dollars by having to ship the long way around the Delmarva Peninsula. Plans were being made to try and dynamite the wreckage out of the water. One man, Richard W. Stasch of Baltimore, watched these failed efforts and offered the government $1,265 for the ship with the stipulation that he remove it within ten days. He would then be awarded the salvaged vessel.

Stasch mortgaged everything to salvage the *F.L. Hayes*. He had noticed that the bow of the ship was still above water. He also knew that there were seven separate tanks along each side of the ship. He believed that if he could pull the ship forward each tank would appear and could be filled with air. The ship would rise up, and eventually the entire vessel would be afloat. He sunk a massive oak log to serve as an anchor while a 250-horsepower tractor pulled the vessel up and out of the water by a series of blocks and tackles attached to its bow. He succeeded where previous attempts had failed, but overall it still took 103 days to clear the canal of the wreckage.

The U.S. Coast Guard report, issued on December 11, 1952, placed the ultimate blame for the accident on the canal itself, not the ships' pilots and captains. It noted, "It is considered that the principle cause of the disaster lay not with the ships involved, but with the canal itself." All required navigation lights and horn signals had been used properly. It pointed out that the canal, only 170 feet wide at the location of the accident, made a dangerous bend. Ships traveling in either direction had to hug the north shore to find deep water and to be able to point their bows correctly in

order to proceed safely under either the railroad bridge or the Summit Bridge. The Coast Guard pointed to the tidal currents as a contributing factor. The two to three knots experienced that night both made handling difficult and ruled out safe anchoring as a collision avoidance technique. The erratic current, sweeping around the bend, would only shove sterns out farther into the waterway.

Congress had the accident report and the report from the Army Corps of Engineers that called for the canal to be widened to 450 feet, with a consistent 35 feet below the waterline. The canal was to be straightened between the Summit Bridge and the railroad bridge, removing the sharp and dangerous bend. The remaining lift bridges would be replaced with highway spans. General Sturgis, the head engineer for the Army Corps of Engineers, said that this expansion "should be undertaken immediately providing a suitable facility for the safe passage of large vessels." He stressed how valuable the canal had been to the nation during World War II and said that the wrecks of the *F.L. Hayes* and the *Barbara Lykes* showed how vulnerable the waterway was. He logically pointed out that the costs of the expansion would only grow if the plan was put on hold. The original estimate of $96 million that was in the 1954 report had grown to an amount exceeding $126 million by June 1957. Congress approved the plan in 1954, but full-scale construction was delayed until 1962. The full appropriations came after a cost-benefit ratio study was completed by the Army Corps of Engineers that showed that benefits would exceed costs by 30 percent. Smaller projects were completed during the intervening years.

The major work consisted of moving another one hundred million cubic tons of dirt and included efforts to deepen the approach channels in both the Delaware River and the Chesapeake Bay. The expansion of the canal to a full 450 feet of width and 35 feet of depth meant that the largest ships then operating could transit the canal freely and could pass other vessels of similar size without restrictions. The dangerous curve near the deep cut was eliminated. Work was finally completed in the mid-1970s.

The canal remains at this size as we enter the second decade of the twenty-first century. A study was conducted by the Army Corps of Engineers in 1996 that researched the feasibility of expanding the canal even farther to a depth of forty feet. This would allow even the modern supertankers access. Additional navigation and environmental improvements, widely supported by local and state politicians, were also called for in the report. One project is to improve the maintenance roads that run along both sides of the canal to allow for more recreational use, primarily hiking, horseback riding and

biking. Currently these unimproved roads are open to the public, but there are no other facilities besides a few fishing piers. The area near the south end of the Summit Bridge is a designated wildlife area, but funds to improve the mud and gravel roads have yet to be found. While the canal carries 40 percent of all traffic in and out of Baltimore, decreased shipping and use of the Port of Baltimore put the study on hold in 2001. Any further improvements will have to wait for a better economy.

THE CANAL TODAY

The Francis Scott Key Bridge carries the Baltimore Beltway high above the Patapsco River and marks the entrance to the Port of Baltimore. The deep-water channel inside or west of the bridge is called the Fort McHenry Channel. Most of the container ships that enter and leave the harbor are tied to the industrial docks located on the north side of the river in the section of Baltimore known as Dundalk. Modern ships don't stay at the dock for long. An amazing amount of freight, shipped in containers, can be unloaded and reloaded in a twenty-four-hour period. It seems as if a ship has only been in port for a few minutes when the harbor tugs begin the process of moving the ship away from the dock and pointing it in the right direction. A Port of Baltimore pilot is on board and in charge of the maneuvers. When they are satisfied, the tugs return to their dock, and the ship moves under its own power through the Key Bridge and out into the Brewerton Channel that continues into the main stem of the Chesapeake Bay. Just moments after the vessel clears the bridge, a small boat comes alongside of the still moving ship. The harbor pilot climbs down the ladder, and a Chesapeake Bay pilot climbs on board. They will be responsible for the safe passage of the ship as it moves up or down the Chesapeake Bay.

A ship heading south will make a slow turn to starboard (right) and head toward the mouth of the bay using the Craighill Channel. Moments after leaving Baltimore, the vessel will pass under the twin spans of the Chesapeake Bay Bridge. The bay pilot will stay with the ship until it reaches Norfolk.

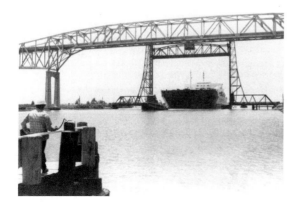

A view that shows a vessel moving through both the railroad lift bridge and under the Summit Highway Bridge. The lens used makes the two appear much closer than they really are.

A northbound ship will bear to port and make a sweeping turn that will place it in a roughly northeast direction. This channel is known as the Tolchester because at one point, following the natural riverbed of the Susquehanna River, it swings in to within one hundred yards of the Eastern Shore near the village of Tolchester.

All of the shipping channels of the Chesapeake Bay require constant dredging, even though they are a natural contour of the ancient, sunken river. The Tolchester Channel is no exception, and most years dredging equipment is in use along the length of the northbound channel.

Modern container ships move at a high rate of speed, and it is only a short period of time before the vessel passes Poole's Island on the left. The vessel is now entering the outer reaches of the C&D Canal. Red and green navigation lights line the channel. Their numbers indicate where the ship is along its journey. White range lights are also located along the channel. The pilot keeps the light on the lower, forward tower, lined up with the next light. This tells them that the ship is straight in the channel because to go out the shipping channel is to invite an accident.

The other issue is pleasure boat traffic. Many boats follow the channel to maintain their course, while others cross it on their way to ports on the Eastern Shore, such as the Sassafras River. Many weekend boaters don't realize the speed of the container vessels and tankers. It takes them as many as five miles to stop. Cutting off a container ship in a small boat is a dangerous and unnecessary maneuver. There is a fatal accident involving weekend boaters and oceangoing vessels almost every year on the Chesapeake Bay.

The northbound vessel passes the entrance to the Sassafras on the starboard side. Elk Neck, with the Turkey Point lighthouse at its pinnacle, appears on the port side. The water narrows as it passes into the Elk River

The Canal Today

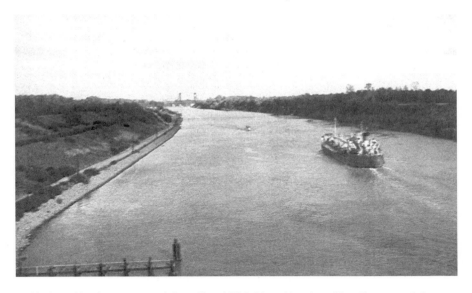

A ship is making its way toward the railroad lift bridge. Ahead, and heading toward the ship, is a small pleasure boat. Recreational boats make up a great deal of the canal's traffic in the twenty-first century.

proper. The pilots must concentrate on the range lights farther up the river. Houses and docks line both shores. The Bohemia River enters on the right. Augustine Herman's original manor house sits at the head of this beautiful Eastern Shore river. It was his vision that resulted in this container ship making this trip.

A few miles past the Bohemia, the ship must make a slight starboard turn, exit the main channel of the Elk and move into Back Creek. Eight miles ahead is Chesapeake City and the actual beginning of the canal. Safe speed and a vigilant watch are required to ensure that vessels transiting the canal, both large and small, can do so safely.

Shipping traffic is down worldwide due to various factors, economic and social, but more than one thousand ships pass through the C&D Canal each year. Statistics kept by the Army Corps of Engineers report that more than fifteen million tons of freight was shipped through the canal in 2007, and twelve million of that was domestic traffic. Petroleum products have replaced coal as the largest single category of goods, but the statistics show that there are still large quantities of other products such as chemicals, building products, forest products, salts, glass, lime, iron and other metals. These figures do not account for the hundreds of pleasure craft that cross through the canal each year.

The canal is operated by the thirty-five employees of the Army Corps of Engineers located in a white frame building in Chesapeake City. Computers and video cameras connected by modern digital networks have replaced bridge tenders and chase boats as the method of keeping track of ships passing through the canal. The dispatcher in Chesapeake City receives a call from ships planning on entering the canal two hours before their estimated arrival. This information is entered into the computer, and the dispatcher will always know what vessels entered the canal, the time they arrived, where they are currently and the estimated times they will exit the canal. This data can be found online or observed on screens located at the excellent canal museum located across the parking lot from the Corps' headquarters.

The container ship is getting closer to Chesapeake City. Activity increases both on the vessel as well as on shore. Here is where the Chesapeake Bay pilot is replaced by the Delaware Bay pilot. Boats still leave the docks at the old Schaffer Canal House to deliver the new pilot and remove the old. The switch is done while the ships are underway. Many people like to sit in the bars and restaurants of Chesapeake City with a view of the canal and watch this exchange.

The Chesapeake Bay pilot returns to shore to wait for a westbound ship that will need his or her services. The Delaware pilot takes responsibility for navigating the container ship through the remaining fourteen miles of the canal. It passes under the remaining bridges. Only the railroad bridge has to be notified to ensure that it is raised to its full height. The canal dispatcher is in contact with his counterpart at the railroad. The ship passes through what was known as the deep cut. The sharp bend has been removed, making for a safer passage. The old bend is now the entrance into the Summit North Marina, where many pleasure boats—power, fishing and sail—are kept for weekend boaters who live nearby.

The ship approaches the east end of the canal at Reedy Point. The original channel veers to the left and goes into Delaware City. Marshlands that caused so much trouble during the years the canal was being built stretch along the southern shore. The ship passes under the Reedy Point (or Route 9) Bridge and enters the Delaware River. There are two choices. One is to turn left and head up the river to the Port of Philadelphia. A new pilot will be used for the approach to Philadelphia. The other choice is to turn southward along the Delaware and New Jersey shorelines and sail toward the Delaware Bay and the open Atlantic. The Delaware pilot will stay with the vessel until Lewes, Delaware, where he will be picked up by a small pilot boat and the continued safe passage of the container ship will be in the hands of the captain until the next port.

The Canal Today

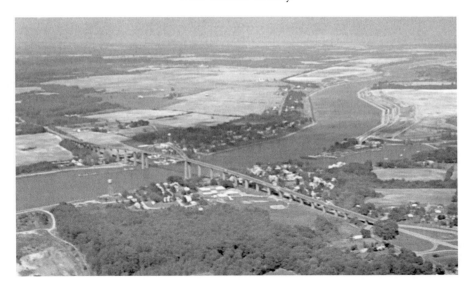

An aerial view looking eastward from Chesapeake City and toward the eastern terminus at Reedy Point. Back Creek runs to the left. The body of water on the south shore is the engineering basin, in which many overnight boaters seek shelter.

The Chesapeake and Delaware Canal has been in operation since 1829. It has seen its share of success and failure. It has been a shaky private enterprise, a successful venture and a government-run operation, but through all of the changes it has been an important factor in the growth of the United States. The removal of a three-hundred-mile trip around the tip of the Delmarva Peninsula improved the economics of shipping in the early days of this country and made both Philadelphia and Baltimore vital ports. It has been an important part of our national security and saved dozens of ships from being sunk by enemy submarines during World War II. It has become an important tourist destination both for land cruisers and boaters. While neither major town, Delaware City or Chesapeake City, ever reached the size and scope originally visualized, the canal has helped to sustain them as viable communities for close to two hundred years.

It is because of visionaries and the hard work of men such as Augustine Herman, Thomas Gilpin and Mathew Carey that the canal even exists. They believed in its value before anyone else and pushed and pulled until it was built. It is hard to imagine what it would be like today if the canal did not exist. It remains one of the most important projects ever undertaken in this country.

BIBLIOGRAPHY

Diggins, Milt. *Cecil County: Images of America.* Charleston, SC: Arcadia Publishing, 2008.

Gray, Ralph D. *The National Waterway: A History of the Chesapeake and Delaware Canal, 1769–1965.* Urbana: University of Illinois Press, 1967.

Hazel, Robert, and David Healey. *The Chesapeake and Delaware Canal: Chronicles of Early Life in Towns Along the Historic Waterway.* Chesapeake City, MD: Rare Harmony Publishing, 2004.

Knauss, Christopher. *Cecil County Maritime.* Charleston, SC: Arcadia Publishing, 2007.

Ludwig, Edward J., III. *The C&D Canal: Gateway to Paradise.* Elkton, MD: Cecil County Historical Society, 1979.

Morgan, Karen, and J. Calvin Titter. *Chesapeake City: A Canal Town through the Years.* Chesapeake City, MD: Briscoe Hill Publishers, 2000.

U.S. Corps of Engineers. *A History of the Philadelphia District—US Army Corp of Engineers, 1866–1974.* Philadelphia, PA: U.S. Corps of Engineers, 1974.

Wilson, W. Emerson. *Fort Delaware*. Newark: University of Delaware Press, 1957.

Wingate, William O. *Reminiscence of a Town that Thought It Would Be a Metropolis*. Dover: Delaware Heritage Press, 1993.

ABOUT THE AUTHOR

D avid Berry has lived and worked in the Lower Susquehanna Valley for a number of years. He's a resident of Havre de Grace, where he teaches sailing and writes. He is published in the *Mariner*, *Sailing* magazine and the *Baltimore Sun* and is the author of two previous books, *Maryland Skipjacks* and *Maryland's Lower Susquehanna River Valley: Where the River Meets the Bay*. Berry also volunteers his time in various local organizations, including the Susquehanna Museum at the Havre de Grace Lockhouse and at the skipjack *Martha Lewis*.

Berry is a graduate of Muskingum College with a bachelor's degree in psychology and holds a master's in business administration from Miami University. He spent twenty-five years as a sales representative and sales executive in the telecommunications industry. He and his wife, Chris, have two grown children: Jason of Dover, Delaware, and Julie, who lives in Wellington, New Zealand, with her husband, Benn.

Visit us at
www.historypress.net